images *of* nature

Expeditions and Endeavours

Andrea Hart and Paul Martyn Cooper

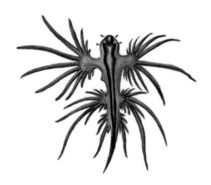

Published by the Natural History Museum, London

First published by the Natural History Museum, Cromwell Road, London SW7 5BD.
© The Trustees of the Natural History Museum, London 2018. All Rights Reserved.

ISBN 978 0 565 09460 7

Internal design by Mercer Design, London
Reproduction by Saxon Digital Services
Printed by 1010 Printing International Limited

Front cover: *Aptenodytes patagonicus*, king penguin
Back cover: *Phascolarctos cinereus*, koala
Back flap: *Acmella grandiflora*
Title page: *Glaucus atlanticus*, sea swallow
Contents page: *Gentianella campestris*, field gentian
p.4: *Dynastes tityus*, eastern Hercules beetle

Note: measurements given in captions are original artwork size.

Contents

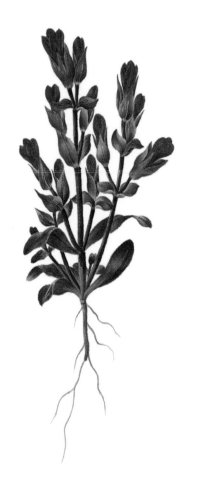

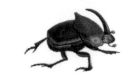

Introduction

The cabinets along the back wall of the Rare Books Room in the Library of the Natural History Museum contain some of the earliest published accounts of natural history travel and discoveries. It is a subject area that has been well documented throughout history. The Library holds nearly 2,000 volumes in this collection and includes, amongst others, George Anson's 1748 account of his voyage around the world, one of the most popular expedition books of its time. What the books all have in common is their contributors' passion and desire to observe, collect, compare and record life on Earth, in the pursuit of furthering our knowledge. These printed records contain descriptions, opinions and accounts – both scientific and personal – of some of the most important, historic and exciting expeditions and endeavours ever to have been undertaken. Their missions were to discover, chart and investigate almost every corner of the Earth and its seas. Just as Anson's did, these accounts also served a practical use: both informing and inspiring later expeditions of discovery and acting as working documents aboard expedition ships.

The early first-hand narratives of individual travellers and organised expeditions were documented in manuscript form, particularly the voyages of the ancient historians and geographers. Following the invention of the printing press in the late fifteenth century, it became possible to preserve these narratives in the printed word. Few of these early printed accounts were illustrated, apart from the occasional map or chart that was often of poor quality or lacking in accuracy. These accounts therefore relied upon the author's descriptive ability to give the reader a visual sense of the discoveries and environs encountered. As valuable as that was for geographical knowledge, once it became possible, and affordable, to include illustrations of what had been observed and collected, the reader was able to engage with the text with a new level of understanding.

The undertaking of expeditions helped both to form and shape the basis of many of the systematic collections found in today's museums and intellectual institutions. In addition to zoological and botanical specimens, soil and other natural products were included in the planning and collecting guidelines for expeditions. Together with science, navigation and trade, another motivation for

European nations such as Britain, France, Spain, Portugal and Holland to dispatch expeditions was to record encounters with other cultures, describing their habits, customs and way of life.

Some individuals also enhanced their own collections by commissioning expeditions themselves or using established trade routes and organisations such as the British East India Company to commission the collecting of specimens. But for many of them, it was through their own personal travel experiences that their interest in and desire to collect the natural world was ignited. Early in his career, Hans Sloane (1660–1753) voyaged to Jamaica as physician to the Duke of Albemarle and collected natural history specimens there – marking the start of the collection that would ultimately form the nucleus

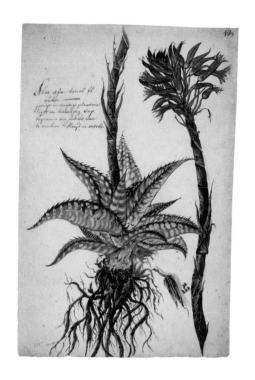

Aloe saponaria, soap aloe

The Cape flora are one of the most diverse ranges of floras in the world with an estimated 9,000 species of flowering fynbos plants, 70 per cent of which are found nowhere else on Earth. This soap aloe is native to southern and eastern South Africa, southeastern Botswana and Zimbabwe. It is from one of the earliest botanical illustration collections held in the Library.

Drawings of Cape plants
Watercolour on paper
c.1685
418 x 271 mm

of the British Museum (and subsequently the Natural History Museum). Lionel Walter Rothschild (1868–1937), a wealthy and eccentric naturalist, became a great commissioner of collectors who in turn helped him develop his magnificent museum and menagerie at Tring in Hertfordshire. Another important and wealthy collector was Joseph Banks (1743–1820), one of the greatest contributors to the Museum's collections. He joined the *Endeavour* that sailed to the Pacific (1768–1771) under the command of James Cook (1728–1779).

At a time when so many new species were being discovered, ordering, classifying and accurately illustrating what was found became a necessity. This was especially important as some specimens did not always survive long journeys or would lose some of their key identifying characteristics at the point of collection. The Library holds a set of botanical drawings from the Cape of Good Hope that was produced towards the end of the seventeenth century by a range of artists. They represent some of the earliest European depictions of the floral diversity of the area and were useful visual tools for the opening up of knowledge about the continent's flora and its economic potential. They also give an insight into pre-Linnaean taxonomy and the scientific style of illustration of the time.

One of the most iconic collections held in the Library is that of the natural history artworks from Cook's three voyages of discovery. The collection is enhanced by the large number of natural

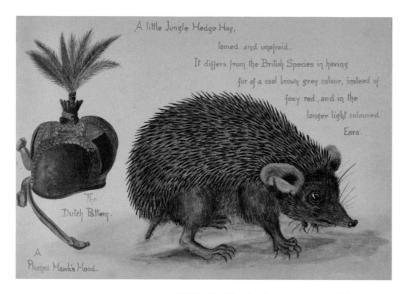

In image: A little Jungle Hedge Hog, tamed and unafraid. It differs from the British Species in having fur of a cool brown grey colour, instead of foxy red, and in the longer light coloured Ears. The Dutch Pattern. A Plumed Hawk's Hood.

Hemiechinus collaris, Indian long-eared hedgehog

Olivia Tonge made two trips to India and Pakistan between 1908 and 1913, capturing her travels and observations in 16 sketchbooks. Her wonderfully vibrant compositions not only demonstrate her artistic skill but her accompanying notes and comments provide us with a richer understanding of her experiences. This south Asian hedgehog is endemic to India and Pakistan where it is the most common species of hedgehog.

Olivia Tonge (1858–1949)
Watercolour on paper
*c.*1908–1913
178 x 258 mm

history specimens collected, many of which are also preserved at the Museum. Significantly for the time, all of Cook's voyages had specially appointed artists on-board such as Sydney Parkinson, Johann Georg Forster, William Ellis and John Webber. These artists have helped us visualise the natural world in its finest detail, and their outputs also significantly changed how Europeans at the time were able to see new lands and cultures. Natural history illustrations were also being created by countless other individuals such as the African explorer Thomas Baines (1820–1875) and the traveller Olivia Tonge (1858–1949) who both produced illustrated accounts which serve as important social and cultural histories of the time.

This book uses the rich collections of the Library to consider the background to such expeditions and endeavours, and how successive voyages and personal travels facilitated new scientific discovery and a greater understanding of the natural world. It also brings together a wide-ranging cross-section of the Library's incredible collections, many previously unpublished, but all of which are survivors of their own incredible journeys to their current resting place in the Natural History Museum.

Cook's voyages

The year 2018 marks the 250th anniversary of James Cook's first voyage of discovery on the *Endeavour*. Over the course of his three voyages around the world, Cook established his reputation as the finest navigator of the time. Through the inclusion of naturalists and illustrators on the voyages he also facilitated the study of natural history across a wide area of the Pacific region.

A natural history role for the *Endeavour* voyage arose due to the influence of Joseph Banks who was described at the time as 'A gentleman of large fortune, well versed in natural history and of great personal merit.' Late in 1767, the Royal Society of London resolved to petition the government to send a ship with observers to follow the transit of Venus from the island of Tahiti in the Pacific Ocean. The transit of Venus is a rare astronomical event in which the planet appears as a small black disc traversing the sun. It was hoped that the study of this phenomenon would help determine, with more precision, the distance of the Earth

from the sun. Banks quickly made known his desire to take part in the expedition. He had been admitted as a Fellow of the Royal Society at the age of 23 and during the summer of 1766 he took part in a voyage to Newfoundland and Labrador and collected rocks, plants and animals. He also enjoyed the friendship and support of senior figures in government and in the Admiralty. His participation was agreed upon in part, if not completely, because Banks was willing to commit a substantial amount of his own money (estimated to be £10,000) towards its costs. Banks funded his own place and employed the services of his good friend and pupil of Linnaeus, the Swedish botanist Dr Daniel Solander, Hermann Diedrich Sporing as secretary and artist, four servants and field assistants and two official artists – Alexander Buchan as landscape artist, and Sydney Parkinson as naturalist artist. The *Endeavour* left Plymouth on the 25 August 1768 with a total of 94 men on-board.

The voyage circumnavigated the world with landings at Madeira, Rio de Janeiro, Tierra del Fuego, Society Islands, New Zealand, Australia, Java, Cape of Good Hope and Saint Helena, returning to England on 12 July 1771. The journey beyond Otaheite (Tahiti) where the Transit of Venus was observed had, in what were initially secret government instructions to Cook, the purpose of seeking evidence of the fabled Southern Continent, also known as Terra Australis Incognita.

Banks quickly established a system for working with the artists. The natural history illustration was principally carried out by Sydney Parkinson with much smaller contributions from Alexander Buchan and Herman Diedrich Sporing. Banks' natural history interests and concerns focused on botany so this determined the emphasis of the collecting throughout the voyage. Banks and Solander highlighted the new or noteworthy specimens for illustration and Banks determined the procedure as he outlined in a letter to his friend Johan Alströmer, 'We sat till dark at the great table with the draughtsman opposite and showed him in what way to make his drawings, ourselves made rapid descriptions of all the details ... while the specimen was fresh.' Banks and Solander collected cultivated plants as well as wild ones. A notable example from Tahiti was the breadfruit tree, which Banks would later introduce to the West Indies. Indeed Parkinson's fine drawing of it was later engraved and included in the official account of the first voyage. Solander ensured, with regard to both plants and animals, that Parkinson paid attention to the anatomical features which would allow the organism to be identified according to the Linnean system of classification.

Gunnera magellanica

This herb grows in shrub formations on the Tierra del Fuego archipelago. It is one of the finished watercolours by Sydney Parkinson, who masterfully captures its bright red berry. It was only described 20 years later by Jean-Baptiste Lamarck in his *Encyclopédie Méthodique* in 1789.

Sydney Parkinson (1745–1771)
Endeavour 1768–1771
Watercolour on paper
1769
361 x 256 mm

Following the death of Buchan on 17 April 1769 from an epileptic fit on Tahiti, Parkinson found himself with an increased drawing workload as he now also had to do the landscape and ethnographical illustrations that Buchan would have undertaken. A larger volume of specimens collected in New Zealand and New Holland (the east coast of Australia) meant that Parkinson only had time to do sketches, with a colour reference, of the botanical specimens. This contrasted with the beautifully finished watercolours he was able to execute in the earlier stages of the voyage.

Tragically Parkinson died of fever on the final leg of the voyage, following the ship's departure from Batavia (Jakarta). He made over 600 botanical and nearly 300 zoological drawings over the course of the voyage. This outstanding visual record of flora and fauna, some not previously depicted, complemented the scientific importance of the specimens collected and Solander's detailed descriptions.

Not long after the return of *Endeavour*, a second voyage was settled upon to continue the search for the Southern Continent, and Banks fully expected to participate in this voyage too. However, the expanded accommodation and personnel for natural history investigation which he wanted proved impractical and he was obliged to withdraw. From this point onwards, rather than being an active participant, Banks developed the role of an encourager and a patron of scientific exploration, including taking a particular interest in the creation of illustrated records of newly discovered flora and fauna. What he had effected, nevertheless, was a change of importance for natural history and one which saw the government's acceptance of the inclusion of a naturalist and a natural history artist in what would be Cook's second voyage to the Pacific in HMS *Resolution* (1772–1775). This voyage journeyed further south than any previous one and, on 17 January 1773, was the first ship to cross the Antarctic Circle. On-board was the naturalist Johann Reinhold Forster and his son, the artist Johann Georg Forster who recorded for the first time petrels and other oceanic birds.

In his third and what would be final voyage, Cook sailed once again in HMS *Resolution*, which had been recommissioned, leaving on 12 July 1776 in search of the Northwest Passage. An illustration in the collection, by John Webber, the official artist on-board, is that of the edible Kerguelen Island cabbage plant, *Pringlea antiscorbutica*, which was first discovered on this voyage by the ship's surgeon William Anderson. Given the high level of mortality associated with sea travel at the time due to scurvy – almost half of George Anson's 2,000 man crew in his voyage of 1640 died from the condition – this was a particularly important discovery as *Pringlea antiscorbutica* contains high levels of potassium as well as having vitamin C-rich oil in its leaves. Its consumption greatly helped those suffering from scurvy, which led to its species name which means 'against scurvy'.

Banks maintained his interest in the Cook voyages, acquiring most of the natural history drawings from all three and a large quantity of the specimens. Out of loyalty to Cook, following his death in Tahiti on 14 February 1779, Banks oversaw the publication of the account of his final voyage.

Voyages of discovery and their visual impact

The motivations behind early explorations were numerous and complex. In the scientific arena, the Age of Enlightenment, at the beginning of the eighteenth century, brought about a new questioning of long-accepted precepts of ancient authority and, with it, new investigations based on observation and reason. By the latter half of the eighteenth century, scientific enquiry had become even more of a motivation and it was this thirst and excitement for knowledge, for new species and in particular those with economic potential, that was to encourage many more voyages to be undertaken.

The establishment of oceanic trade routes opened up the seas to those wanting to travel, and increased the opportunities for individuals to undertake their own expeditions. The British East India Company, founded at the start of the seventeenth century by Royal Charter, was a key developer of these routes. Initially established to develop trade with the East Indies, or maritime Southeast Asia, it became a territorial power in the Indian subcontinent during the eighteenth century. Its commercial aims benefitted from advances in science such as botanical discovery and the charting of navigational routes.

Indeed, Joseph Banks persuaded the governors of the Company to contribute to the costs of Matthew Flinders' circumnavigation of Australia on-board the *Investigator* (1801–1803). The Company therefore not only facilitated travel but in so doing enabled the further assimilation of collections and dissemination of knowledge of natural history, particularly through the members in its service serving in its overseas offices – some of whom were given explicit instructions to collect for the Company's museum. These included the American doctor Thomas Horsfield (he also collected for Banks) who became curator of the Company's museum. Known simply as the India Museum, it was established at the Company's headquarters in London in 1801 and held one of the most extensive collections of the natural history, arts and sciences of Asia in the nineteenth century. Following the disbanding of the Company during the 1870s, the museum's contents were absorbed into other national collections including the British Museum, Kew Gardens and the Natural History Museum.

The illustrations held in the Museum Library which originated from the British East India Company's activities, represent some of the largest collections of natural history illustrations amassed during the period and include one of the Museum's oldest collections of illustrations and specimens. These belonged to Paul Hermann (1646–1695) who served in the Dutch East India Company as a medical

officer in Sri Lanka. One of the first major collections of the botany of the East Indies, Hermann's four volumes of dried botanical specimens are accompanied by a single volume of incredibly detailed pen and ink wash illustrations. These historically important collections were studied by Linnaeus prior to their purchase by Banks in 1793.

Other collections include those of William Henry Sykes (1790–1872), an army officer and naturalist who undertook a major survey of the Deccan region in India during the 1820s, and Nathaniel Wallich (1786–1854), a Danish surgeon and the director of the Company's botanic garden in Calcutta. The Library's largest collection of botanical illustrations, an impressive 1,100 drawings, was amassed by John Reeves (1774–1856) and it predominantly features Chinese plants of economic and horticultural importance. This collection also contains over 500 zoological drawings, all of which were carried out by local artists under the supervision of Reeves during his tenure as Tea Inspector in Canton.

Military postings within the British East India Company enabled individuals to pursue their own interests. The Scottish palaeontologist Hugh Falconer (1808–1865) worked as assistant surgeon for

the Company in Bengal and in 1831 he discovered bones of crocodiles, tortoises and other animals in the fossil beds located in the Siwalik Hills. Thomas Hardwicke (1756–1835) was stationed in India, which provided him with the opportunity to travel extensively over the subcontinent and collect numerous natural history specimens and illustrations commissioned from local artists. Likewise, Robert Wight (1796–1872) also travelled to India in 1819 as an assistant surgeon where he remained for 30 years following his appointment as the Director of the Botanic Garden in Madras. Drawing on the skills of native artists, he formed a collection of over 700 botanical illustrations. His aim was to produce a classified flora of India, though the work was never completed.

Outside military postings, Brian Houghton Hodgson (1801–1894) initially travelled to India as writer for the British East India Company prior to his appointment as British Resident in Nepal in 1833. Whilst in Nepal he studied ethnology, anthropology, Buddhism and all aspects of natural history, collecting a substantial number of zoological

specimens. He also trained Nepalese artists, including his principal artist Rajman Singh, to scientifically illustrate some of the first depictions of local birds. Hodgson identified new species of mammals too, but as a result of the communication difficulties at the time, in part caused by his geographical remoteness, many were subsequently attributed to other zoologists.

John Bradby Blake (1745–1773) was an English botanist who travelled to China for the Company, overseeing their cargo and its sale. His interest in natural science led him to select the seeds of local plants and vegetables of economic and medicinal use and send them back to Britain for propagation, some of which were successful. There is an illustration in his collection of the tea plant, *Camellia sinensis*, which is native to East and Southeast Asia and the Indian subcontinent, but is now cultivated across the world. Its genus name was given by Linnaeus in 1753 from the latinised name of Georg Kamel (1661–1706), a Jesuit pharmacist and missionary to the Philippines who produced the first comprehensive accounts of the flora and fauna of the Philippines. Jesuits were members of the Society of Jesus, a Christian male religious order of the Catholic Church founded by Ignatius of Loyola in 1540 to communicate and promote the Christian faith, social justice and apostolic ministry in six continents. This enabled its missionaries not only to travel but also to pursue their interest in natural history. Established during a time of both scientific revolution in Europe and colonial venture in eastern Asia, the movement is credited with transmitting Western science to China and bringing Eastern knowledge to Europe. This knowledge was represented visually in the form of maps and illustrations such as Kamel's unpublished pen and ink wash illustrations of plants.

Kamel's illustration and botanical collections came to the Natural History Museum via the great collector Sir Hans Sloane. New plants, especially exotic ones for both the economic and horticultural trade, became important commodities as well as being studied for science, and this led to individuals being specifically sent out as collectors. One early plant collector was the Scottish botanist Francis Masson (1741–1805) who was Kew Garden's first plant hunter. Funded by Banks, he travelled on-board Cook's HMS *Resolution* in 1772 as far as the Cape where he remained for three years during which time he sent back over 500 species of plants.

The flourishing nursery trade also placed demands upon the discovery and supply of exotic new species of plants. Frederick William Burbidge (1847–1905) was a talented draughtsman who, in addition to publishing a book on botanical drawing in 1872, was sent out to Borneo in 1877 by the Veitch family, nursery owners who employed plant hunters to collect new plants. It was there that Burbidge discovered many new species including pitcher plants, orchids and ferns and he brought home nearly 1,000 species as dried specimens which were subsequently presented to Kew Gardens. His sketchbooks of Orchidaceae and accompanying notes are testament to his botanical knowledge and skills.

Gavialis gangeticus

These pen and ink illustrations are from a specimen that was collected by Scottish palaeontologist Hugh Falconer. Falconer's collection of drawings features many more examples of fossil Mammalia which he discovered and described from the Siwalik Hills in India.

Hugh Falconer (1808–1865) drawings collection
Watercolour on paper
1859
370 x 273 mm

Individual expeditions and endeavours

As travel became easier, many individuals, often without the backing of a government, employer or sponsor undertook their own expeditions of discovery and natural history investigation, sometimes within their own countries.

LEFT TO RIGHT: *Osmanthus americanus*, devil wood or wild olive; *Cardinalis cardinalis*, northern cardinal; *Pyrus angustifolia*, crab apple; *Micropogonias undulatus*, Atlantic croaker

William Bartram was highly influenced by his father John Bartram in his desire to travel and explore during a time when plant introduction and cultivation was at its peak. Bartram's illustrations and compositions were influenced by his travels, demonstrating how he perceived the natural world and its ecological cycles.

William Bartram (1739–1823)
Ink on paper
1772
181 x 304 mm

In America, William Bartram (1739–1823), the son of Quaker farmer and nurseryman John Bartram (1699–1777), travelled extensively through Georgia and Florida. William kept a journal which he published as *Travels through North and South Carolina, Georgia, East and West Florida...*, in 1791. A plant and seed collector just like his father, he significantly influenced the shaping of science in America in the post-revolutionary era. His accounts also considered the wider aspects of his encounters, describing the lifestyles and culture of the Native Americans, while his artworks portray the relationships and interdependencies between the animals and plants he observed. This was in contrast to William Young (1742–1785) who had accompanied his parents from Germany to America where they became neighbours of the Bartrams. Influenced by John Bartram's seed business, Young established his own seed business which eventually brought him to the attention of Queen Charlotte of England and he travelled to England where he was appointed as the Queen's Botanist. In 1767, he sailed back to America where he collected and illustrated plants in North Carolina, returning to England the following year with over 100 living plants and 300 drawings. Among them were several specimens of *Dionaea muscipula* (Venus flytrap) – the first living specimens of this plant to reach Europe.

Opportunities for women to travel were not so easy to come by, especially as they were not permitted to sail as part of ships' crews. Some accompanied their husbands on their travels such as Dorothy Talbot to Africa, Lady Cust to the West Indies and Lady Edith Blake to Jamaica where she illustrated the Jamaican

Lepidoptera. Others undertook their own expeditions of exploration and include the renowned Maria Sibylla Merian (1647–1717) to Dutch Surinam, Margaret Mee (1909–1988) to the Amazon and Margaret Fountaine (1862–1940), an accomplished illustrator whose love of natural history inspired her to travel and collect extensively throughout the world. It has been estimated that she collected in 60 countries on six continents during her lifetime. Her particular passion was for butterflies which she reared and observed, and illustrated in her sketchbooks.

For men, military service was an option; this enabled them to travel and undertake natural history investigations and research. After working as an official war artist in Cape Town for the British Army, British-born explorer Thomas Baines (1820–1875) joined Augustus Gregory's Royal Geographical Society sponsored expedition across northern Australia as official artist and store keeper between 1855–1857. This left him in good stead to accompany the missionary explorer David Livingstone (1813–1873) along the Zambezi in 1858. Baines' illustrations provide valuable insights into colonial life in southern Africa and Australia.

Africa was also the destination of Johann Martin Bernatz (1802–1878), the German artist who accompanied Captain William Cornwallis Harris (1807–1848) on a British diplomatic expedition to Ethiopia from 1841–1843 as the official expedition artist. Cornwallis Harris had previously joined the army of the East India Company and was initially posted to several places in India where he developed a passion for field sports and illustration. During 1836 and 1837 he visited southern Africa and undertook his own travels there the following year. His drawings of the scenery, game and wild animals of southern Africa and associated publications offer a fascinating view into the region's natural environment as did his collecting which he undertook on a 'ruthless scale' prior to his early death at the age of 41.

The undertaking and planning of expeditions was a long process and success was not always guaranteed. Early travel was often perilous with many lives lost and sometimes entire collections. Alfred Russel Wallace (1823–1913) suffered the misfortune of losing many of his specimens and associated notes in a shipwreck following a fire on his ship in 1852 on his return from South America. Forced to abandon ship, Wallace and his crew spent the next 10 days adrift and all he was able to save was some of his notes along with four volumes of his original fish illustrations from the Amazon. Another unlucky explorer was Louis Auguste Deschamps (1765–1842) who sailed in search of the ill-fated expedition of Jean-Francois de La Perouse. Deschamps not only failed in his mission but 89 of the 119 crew perished during the voyage including the captain, the Chevalier d'Entrecasteaux. Upon reaching Java, Deschamps abandoned the expedition and focused on studying the island where he had previously discovered the plant, *Rafflesia*. Further bad luck ensued when his notebooks were either lost or confiscated on his return voyage to France. Wallace and Deschamps were luckier than the Scottish explorer

Sketch of a mangrove swamp

The Baines collection of watercolours demonstrates Thomas Baines' skills as a scenic and portrait artist. They include various scenes of his travels in southern Africa and depictions of his subjects using a background setting, not just individual subjects. This illustration shows the incredibly complex root system of mangrove trees.

Thomas Baines (1820–1875)
Watercolour on paper
1859
378 x 265 mm

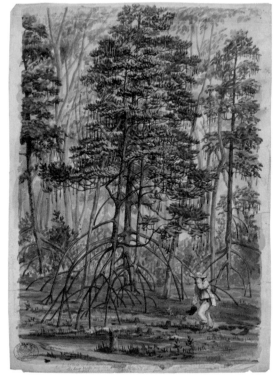

Mungo Park (1771–1806). In 1795, supported by Banks, he departed for West Africa to discover the source of the Niger River. It was a journey full of difficulties but he returned and his narrative titled *Travels in the Interior of Africa* was a best seller. During his return expedition in 1805, however, he was ambushed by hostile natives and in their attempt to escape, Park and his party drowned in the river.

Exploring the seas

One of the earliest original depictions of life in our oceans within the Library collections is a single sheet featuring five illustrations of the Greenland right whale (now known as the bowhead whale, *Balaena mysticetus*) which Sigismund Bacstrom (*c*.1750–1805) drew in 1786 during one of his numerous voyages to Greenland. A trained doctor, it is unsurprising that the meticulous precision of his artistic endeavours bring to mind the skills of a surgeon and scientist as opposed to those of a trained artist. Following his arrival in England in 1770 after serving in the Dutch navy, Bacstrom found employment as Banks' secretary between 1772–1775 and accompanied him on a scientific expedition to Iceland – the first of many voyages that he undertook in the following decade which included trips to Greenland (Spitsbergen), Guinea and Jamaica.

Conducting coastal examinations, taking regular temperature and depth readings and surveying the ocean were repetitive, laborious and demanding tasks due to the exactness required. But they were also essential to further knowledge of uncharted coastlines and new lands with the potential for trade and settlement. Over the centuries, many ships have embarked on expeditions in vessels belonging to the Royal Navy, with the *Endeavour* being the most famous. The Library also holds visual accounts and journals from some of the lesser known expeditions, such as HMS *Blossom* (1825–1828) which sailed to the Pacific Ocean and Bering Straits under the command of Captain Beechey. William Smyth (1800–1877) was a mate on this voyage and his watercolour drawings and notes on vertebrates have been preserved. The Library also has the illustrations of Arthur Adams (1820–1878), who served as both assistant surgeon and naturalist on-board HMS *Samarang* (1843–1846) which surveyed the islands of the Eastern Archipelago under the command of Edward Belcher.

The most significant expedition towards the end of the nineteenth century, which would change the nature of oceanographic and marine exploration, was that of HMS *Challenger*. This expedition departed Portsmouth on 21 December 1872 with the Scottish zoologist Charles Wyville Thomson (1830–1882) appointed as chief scientist. Almost four years in length, it was an arduous but ground-breaking voyage which brought together many different areas of marine science. It was also unique in that it was the first to carry an official photographer in addition to an official artist.

The expedition was not without its casualties. Artist Rudolph von Willemoes-Suhm (1847–1875) died between Hawaii and Tahiti following a short illness. His skilful illustrations, sketches and diary are preserved in the Library along with many other manuscript items from the voyage including, sounding and log books and the letters of Joseph Matkin (1872–1876), which provide an insightful narrative of life on-board. Interestingly, much of the analysis of the data and specimens of the expedition was completed by experts not on the voyage, following its return. Russian-born surgeon and zoologist George Busk (1807–1886) filled vast volumes of notebooks with illustrations of polyzoa on which he was the leading authority at the time. Despite not being on the voyage, he authored the *Report on the Polyzoa Collected by HMS Challenger during the Years 1873–1876,* published in two volumes in 1884 and 1886. Likewise, Georg Ossian Sars (1837–1927), a Norwegian expert on crustacea, worked on the *Challenger* material to produce a report on schizopoda that was published between 1885 and 1887. That the scientific reports of the voyage were eventually published in a total of 50 volumes over a period of 20 years was thanks to the phenomenal efforts of John Murray (1841–1914), who did sail on the voyage and who took over as Director of the *Challenger* offices following the death of Charles Wyville Thomson in 1882.

The *Challenger* expedition was not the only expedition where the analysis of specimens and production of illustrations was undertaken post-voyage. Following the return of the *Terra Nova* (1910–1913) expedition to the Antarctic, Dorothy Thursby-Pelham (1884–1972) completed a set of delicate graphite illustrations of the embryos of emperor penguin eggs that had been collected during the voyage. She did this in her role as assistant to Dr Richard Assheton (1863–1915), an expert in animal embryology who had been assigned to work on them in the hope of finding an evolutionary link between birds and reptiles. The eggs, which were collected by Cherry Apsley-Gerrard, Edward Wilson and Henry Bowers from the South Pole, did not prove the theory but remain preserved in the Museum's collections.

Antarctica has long fascinated explorers and scientists. Joseph Hooker (1817–1911) journeyed there for his first expedition with James Clark Ross in the ships HMS *Erebus* and HMS *Terror*. It was an expedition that enabled him to establish his scientific reputation prior to his appointment as

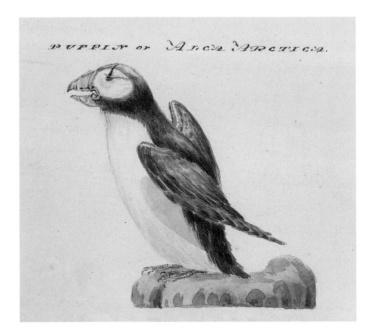

Fratercula sp., puffin

William Smyth voyaged to the Pacific Ocean and Bering Straits from 1825 to 1828, after which he published his two volume report in 1831. Based on where the HMS *Blossom* sailed, this bird is probably the horned puffin, *Fratercula corniculata*, however, as the drawing is not detailed enough, it may also be the Atlantic puffin, *Fratercula arctica*. This demonstrates the importance of accurate scientific illustration to allow for classification.

William Smyth (1800–1877)
Watercolour on paper
*c.*1826
185 x 227 mm

Assistant Director at Kew. But it was Scott's *Discovery* expedition to Antarctica (1901–1904) that significantly increased the existing scientific and geographical knowledge of the continent. The interest in the continent grew to the extent that the subsequent *Terra Nova* expedition received over 8,000 applicants with just 65 men selected for the eventual ship's crew. Edward Wilson (1872–1912) was appointed the expedition's chief scientist and he was not only a qualified doctor and zoologist but also a talented illustrator. He had also joined Scott in a similar albeit junior role on the previous *Discovery* expedition. Unlike the *Discovery* expedition, which had been institutionally funded, the *Terra Nova* was privately funded along with a government grant and its aims were to carry out extensive exploration and scientific experiments. Despite Captain Robert Scott, Edward Wilson, Lawrence Oates and Henry Bowers perishing as part of the party to the Pole in 1912, the scientific work continued on the expedition's return and provided further knowledge and understanding of this harsh and unforgiving continent. As with the *Challenger* expedition, post-expedition work was undertaken and this included analysis of specimens and illustrations by Walter Garstang (1868–1949).

Other visits to the region include that of Leonard Harrison Matthews (1901–1986) who travelled to South Georgia from 1924 to 1929 to study the biology of whales and southern elephant seals as part of one of the British Colonial Office's funded *Discovery* investigations. His watercolour illustrations depict only the heads and feet of South Georgian birds but, like many others before him, he went on to publish many books based upon his experiences.

Published accounts of voyages and expeditions

A browse through natural history books or journals of the mid to late eighteenth century reveals descriptions, usually accompanied by illustrations, of plants or animals with a scientific name as allocated by Linnaeus or based on Linnaean principles of classification, that is a generic name followed by a species name. This conformity of approach to describing the natural world facilitated the exchange of information between naturalists internationally as well as providing a framework for developing and organising knowledge in natural history.

Illustrations were undertaken in order to be used as a form of scientific communication and, on occasion, multiple copies were made. Such illustrations would have been sent to friends, fellow naturalists and interested societies in order to portray and communicate new species to a wider audience, particularly if there was no intention to publish them. Unpublished discoveries, however, inevitably restricted the images and descriptions to a smaller audience.

Epidendrum elongatum, Wiñay Wayna orchid

The orchid *Epidendrum elongatum* occurs in montane forest (up to two miles above sea level) in the Neotropics. The specimen Sydney Parkinson painted was collected by stealth from the vicinity of Rio de Janeiro, Brazil as the Portuguese Viceroy refused to allow the *Endeavour* to weigh anchor in the harbour.

Sydney Parkinson (1745–1771)
Endeavour 1768–17/1
Watercolour on paper
1768
465 x 274 mm

The publishing of scientific reports was incredibly important therefore to enable the new information to be shared. The impacts of not publishing were sometimes significant, with illustrations losing status or relevance as a result, and those who made original descriptions and determinations not being rightfully credited. There are many notebooks and diaries that remain unpublished, and in some instances, later researchers have created accounts based upon them and in turn these accounts have become the authoritative record. What is evident, however, is that the publication of expedition reports and accounts not only demonstrated the increasing interest in the science of many voyages but simultaneously encouraged them.

As with the narrative accounts of newly explored areas, illustrations and images prepared either during or upon the return of an expedition held great impact. But, not all reports reached the stage of publication – this was especially true of the botanical descriptions and artworks brought back from Cook's first voyage the *Endeavour* (1768–1771). The *Endeavour* voyage had allowed Banks and Solander to collect in almost entirely botanically virgin territory. Solander's careful descriptions alongside Parkinson's illustrations (augmented by the work of other natural history artists who made finished versions where Parkinson had left only sketches) should have resulted in one of the most splendid and authoritative botanical books of the eighteenth century. By late 1784 Banks indicated that only a small amount of engraving remained to be done before printing could start. The reasons for the failure of a published account are various, including the background of unfavourable economic conditions in Britain and Europe at the time, quite apart from actions or choices for which Banks was responsible. Banks was, however, generous in allowing the natural history community access to the *Endeavour* notes, descriptions and specimens. He even sent impressions of some of the engraved plates to the naturalist Simon Pallas in Russia. In a project of extraordinary longevity, the Australian plant drawings were published in a lithographed version in three volumes by the Natural History Museum from 1900 to 1905. Between 1984 and 1987 the Museum published a catalogue of the *Endeavour* collection materials (specimens, manuscripts, drawings, copper plates) and in association with Alecto Editions, the project culminated in the publication of a portfolio of the botanical drawings printed from the original copper plates, in colour, which became known as *The Banks Florilegium*.

Despite the failure to publish his *Florilegium* for various reasons, Banks had assisted the British East India Company in an illustrated publishing project which had a particularly successful outcome. In 1784 Patrick Russell (1726–1805), who held the Company post of Natural Historian in the Presidency of Madras, made an initial proposal to prepare a book on the 'curious and useful plants' of the Coromandel coast (the coastal strip of southeast India). During 1788, Banks was asked for advice on the logistics and likely cost of printing it. Banks' careful estimates included the distinction that a fascicule of 20 plates of plants could be sold at £1/5s 'if elegance is adopted' or £1/1s 'if ordinary Workmanship' only was required. William Roxburgh succeeded Russell in 1790 and over the next four years he sent to London drawings executed by Indian artists, descriptions and dried plants of more than 500 species. Banks oversaw, on behalf of the Company, the printing and publication process for *Plants of the coast of Coromandel*. In a way that had previously evaded him, Banks successfully brought together the work of collecting, describing and illustrating from far overseas and turned these in to a published work which fully reflected all those activities.

Publishing was therefore an endeavour in itself and this can be observed through some of the more extensive reports and books produced in the name of natural history. Francis Sarg collected specimens and undertook illustrations of Araneida for Frederick Du Cane Godman and Osbert Salvin's *Biologia Centralia-Americana* which was published in 63 volumes between 1879 and 1915. Although there is no indication that the wealthy Dutch merchant and entomologist Pieter Cramer (1721–1776) travelled, he cleverly utilised the trade links of the time and collectors in order to help him amass an incredibly extensive collection of natural history specimens, and in particular insects from the Dutch colonies such as Surinam, Java, Ambon and Ceylon (now Sri Lanka). As Cramer wanted a permanent record of his important and valuable collection, he engaged the artist Gerrit Wartenaar Lambertz (1747–1803) to illustrate his collection of moths and butterflies for publication in the 33 part publication *De uitlandsche Kapellen* which was funded by Cramer and produced by Caspar Stoll (d.1791). There are 1,658 species of Lepidoptera alone illustrated in this key historical entomological publication.

This is in contrast to John Abbot (1751–c.1840) the British-born entomologist who left for America in 1773 to study and collect natural history specimens and who remained there for the rest of his life. After spending two years initially in Virginia, he moved to Georgia where he settled and went on to illustrate many thousands of insects and produce a volume of bird drawings. Despite this accomplishment, coupled with the misfortune of many bird and insect specimens getting lost at sea in their transit to Britain and Europe, Abbot only managed a single publication in his lifetime. Entitled *The Natural History of the Rarer Lepidopterous Insects of Georgia*, it was published in 1797 with the

botanist and founder of the Linnean Society James Edward Smith – Abbot provided illustrations for the 104 plates and observations of his subjects. More successful was Henry Walter Bates (1825–1892), a close friend of the naturalist Alfred Russel Wallace, who spent 11 years exploring the rainforests of the Amazon, which culminated in his publication *The Naturalist on the River Amazons* in 1863. From the extensive notes and illustrations he prepared during his expedition, he was able to create a book in two volumes which described his time there along with notes on the flora, fauna and social encounters of his travels. To this day it is widely regarded as one of the finest accounts of natural history travels.

Conclusion

In the course of his second voyage, while still seeking the Southern Continent, Cook wrote, 'no man will venture further than I have done, and the land to the South will never be explored'. As we know, Cook was mistaken in this belief and our knowledge of the Earth, the seas and nature has continued to grow, aided by technological advances.

The manuscript accounts of expeditions of the past and the original drawings which were often made en route or in the field, are a vivid reminder of the endeavour and struggle that was frequently involved in natural history discovery and recording. We can only marvel at the ingenuity of those travellers and artists and admire the scientific and artistic achievement of their work. In turn, the drawings and the published accounts which were made remain fascinating visual records and continue to reveal new insights into the expeditions and endeavours of the past.

Bibliography

CARTER, Harold B. *Sir Joseph Banks, 1743–1820*. British Museum (Natural History), London 1988.
DIMENT, Judith A. et al. *Catalogue of the natural history drawings commissioned by Joseph Banks on the Endeavour voyage, 1768–1771 held in the British Museum (Natural History), Pts. 1 & 2*. British Museum (Natural History), London 1987.
HAYCOX, Stephen et al. *Enlightenment and exploration in the North Pacific, 1741–1805*. University of Washington Press, Seattle 1997.
SAWYER, Frederick C. *A short history of the libraries and list of manuscripts and original drawings in the British Museum (Natural History)*. British Museum (Natural History), London 1971.
WHEELER, Alwyne. *Catalogue of the natural history drawings commissioned by Joseph Banks on the Endeavour voyage 1768–1771, held in the British Museum (Natural History), Pt. 3, Zoology*. British Museum (Natural History), London 1986.

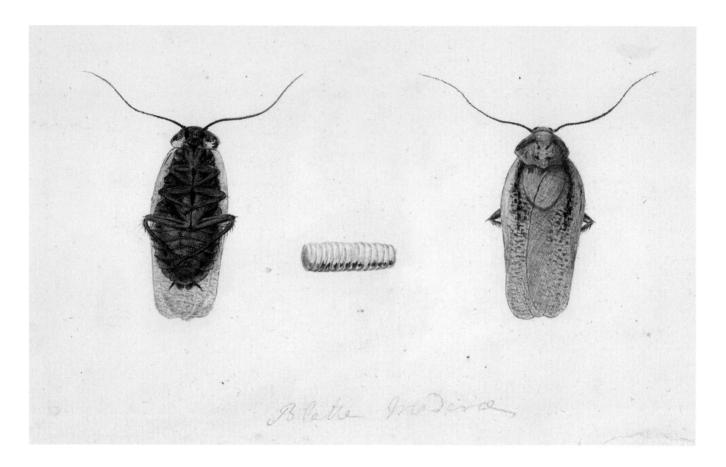

Rhyparobia maderae, Madeira cockroach

Alexander Buchan was one of the official artists aboard *Endeavour*. Tragically he died following a fatal epileptic seizure less than a year into the voyage. Cockroaches frequently infested ships along with lice, maggots and rats, all of which caused considerable damage, particularly to food supplies.

Alexander Buchan (d.1769)
Endeavour 1768–1771
Watercolour on paper
c.1768–69
133 x 232 mm

Physalia physalis, Portuguese man-of-war

Daniel Solander and Joseph Banks captured several specimens of *Physalia physalis* (the Portuguese man-of-war) in the Atlantic Ocean during 1768 and Banks made extensive notes on it. Sydney Parkinson has captured perfectly the appearance of the tendril-like membranes of the organism as it steers itself through the sea.

Sydney Parkinson (1745–1771)
Endeavour 1768–1771
Watercolour on paper
1768
371 x 270 mm

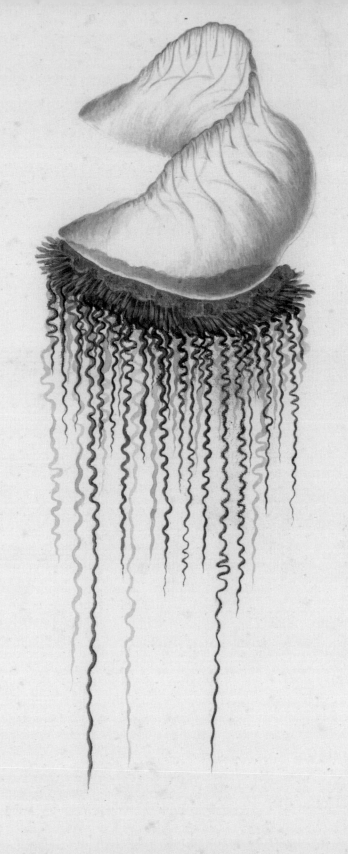

Holothuria Physalis.

Sydney Parkinson pinx.t 1768.

pepe te tata

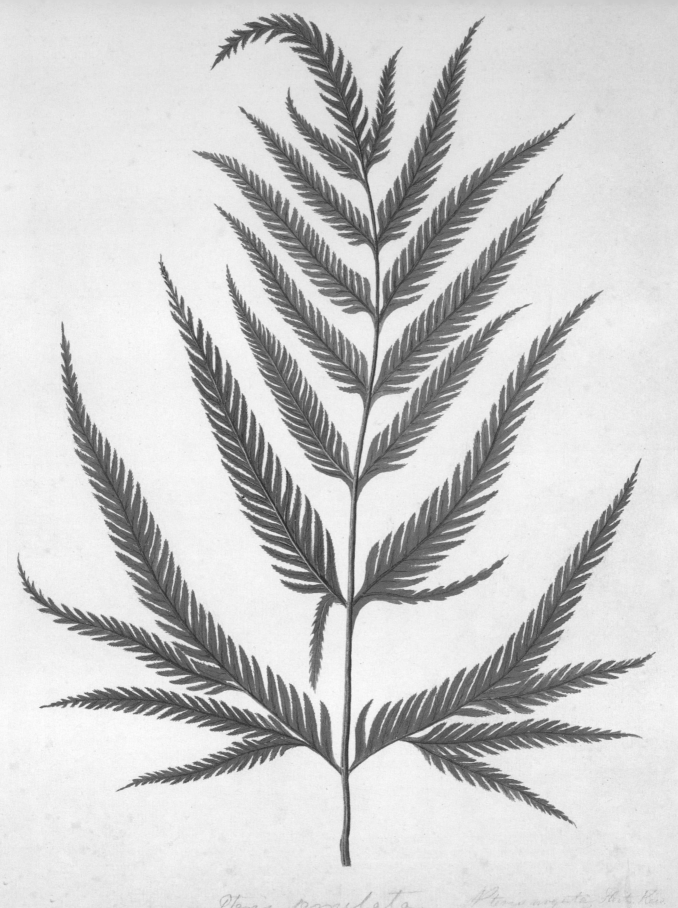

Pteris aculeata *Pteris augusta Hort. Kew*

Osmunda maderiensis

T. 62. Madeira

Pteris arguta

This fern, *Pteris arguta*, was painted by
Sydney Parkinson along the Portuguese
archipelago (at Madeira) in September
1768. Joseph Banks and Daniel Solander
were greatly assisted in their collecting there
by the Royal Society Fellow Dr Thomas
Heberden, chief physician on the island
group. The fern was described in *Hortus
Kewensis* in 1789, the published record of
the plants growing at Kew Gardens.

Sydney Parkinson (1745–1771)
Endeavour 1768–1771
Watercolour on paper
1768
364 x 255 mm

Aechmea nudicaulis

The *Endeavour* reached Brazil on
13 November 1768 anchoring in Rio de
Janeiro's Guanabara Bay in order to replenish
supplies. Two specimens of this bromeliad
from the voyage are preserved in the
herbarium collections at the Museum.

Sydney Parkinson (1745–1771)
Endeavour 1768–1771
Watercolour on paper
1768
364 x 255 mm

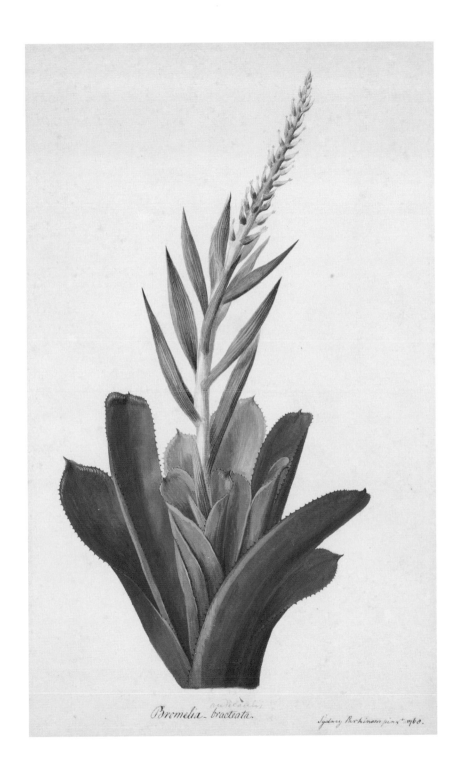

Bromelia bractiata.

Sydney Parkinson pinx. 1768.

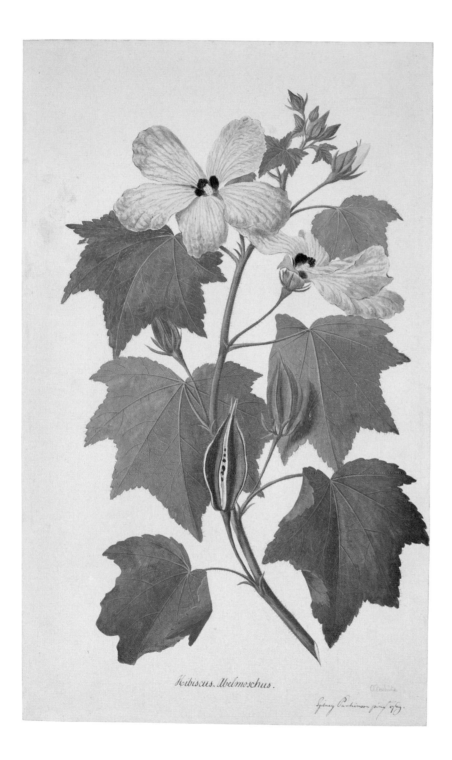

Hibiscus. Abelmoschus.

Sydney Parkinson pinx 1769

Abelmoschus moschatus, abelmosk

Sydney Parkinson painted a specimen of *Abelmoschus moschatus* during the period of April to July 1769 in the Society Islands. The plant has edible uses – young leaves and shoots, seedpods and seeds can all be eaten or used for flavouring. The plant is also used in herbal medicine.

Sydney Parkinson (1745–1771)
Endeavour 1768–1771
Watercolour on paper
1769
463 x 283 mm

Melicytus ramiflorus, māhoe or whiteywood

Melicytus ramiflorus was among the large number of specimens collected by Joseph Banks and Daniel Solander in New Zealand and it is endemic to that country. It is a small tree which produces pleasantly fragranced flowers in the late spring. These are followed by violet-coloured berries which are eaten by birds and occasionally geckos.

Sydney Parkinson (1745–1771)
Endeavour 1768–1771
Watercolour on paper
1770
525 x 357 mm

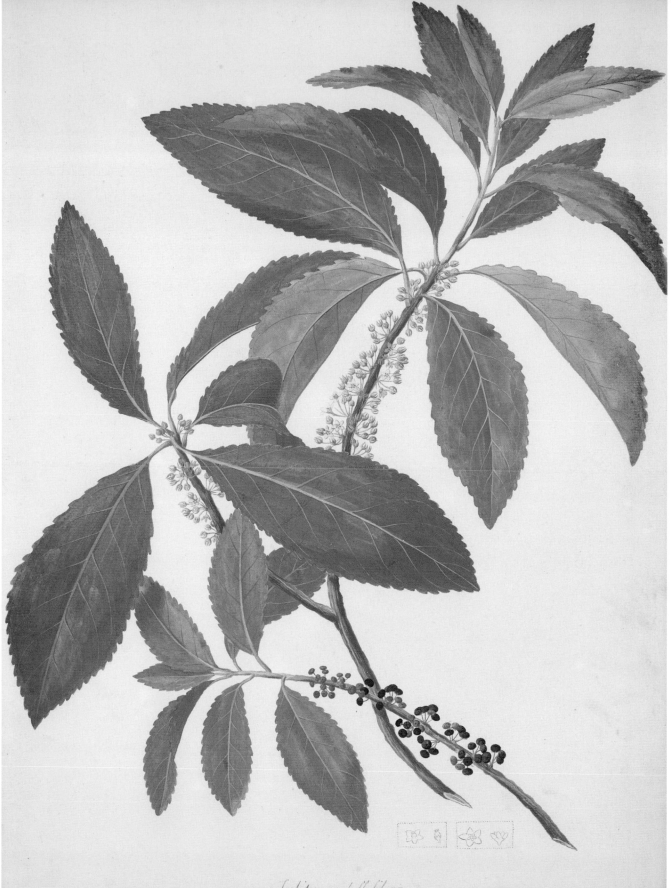

Sachites umbellulifera.

Sydney Parkinson pinxt 1770.

Acmella grandiflora

Joseph Banks and Daniel Solander collected a specimen of *Acmella grandiflora* in the area of the Endeavour River, New South Wales. It continues to grow there as well as in swamps and wet areas, and in some more northerly Australian locations, but is uncommon. Sydney Parkinson made an outline pencil drawing with touches of colour for reference. He needed to follow this working method due to the large numbers of plant specimens Banks and Solander were gathering.

Sydney Parkinson (1745–1771)
Endeavour 1768–1771
Graphite and watercolour on paper
*c.*1770
468 x 285 mm

Acmella grandiflora

This finished watercolour of *Acmella grandiflora* was made by Frederick Polydore Nodder in London in 1779. Nodder was one of a number of artists Joseph Banks employed to complete the *Endeavour* plant drawings. He also made very fine drawings of animals for the English naturalist George Shaw's *The Naturalist's Miscellany*.

Frederick Polydore Nodder (fl. 1767–1800)
Endeavour 1768–1771
Watercolour on paper
1779
545 x 378 mm

Sarcolobus globosus

Sydney Parkinson sketched the shrub *Sarcolobus globosus* from a specimen collected on Princes Island, Java at the beginning of 1771. The seeds are poisonous but the leaves have been used in traditional Indonesian medicine as they have an antioxidant property.

Sydney Parkinson (1745–1771)
Endeavour 1768–1771
Graphite and watercolour on paper
1771
520 x 355 mm

Sarcolobus globosus

John Frederick Miller made the finished watercolour of *Sarcolobus globosus* in London in 1774. Miller was one of a number of artists employed by Joseph Banks to illustrate the plants collected on the *Endeavour* voyage. Miller also accompanied Banks to Iceland in 1772 in the role of botanical artist.

John Frederick Miller (1759–1796)
Endeavour 1768–1771
Watercolour on paper
1774
517 x 350 mm

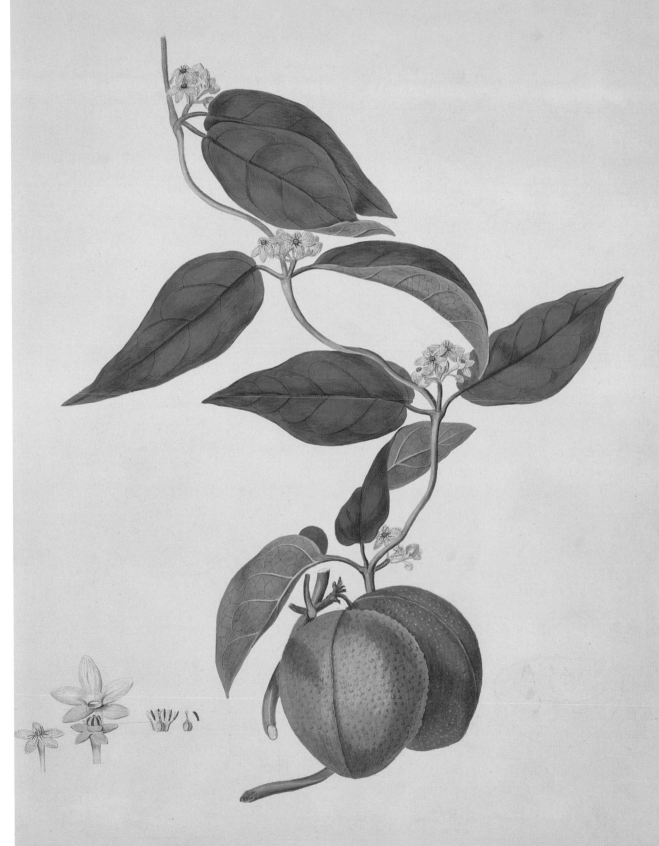

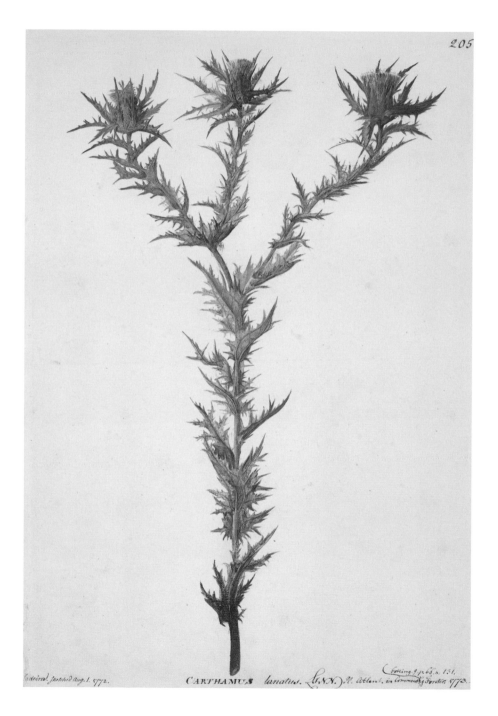

Carthamus lanatus, saffron thistle

Johann Georg Forster painted a specimen of *Carthamus lanatus* on Madeira during August 1772. This thistle is an annual plant and is native to the Mediterranean Basin. Its tangled fibres can sometimes give the appearance of the plant being covered by a spider's web.

Johann Georg Forster (1754–1794)
HMS *Resolution* 1772–1775
Watercolour on paper
1772
392 x 269 mm

Aptenodytes patagonicus, king penguin

Father and son, Johann Reinhold and Johann Georg Forster first had the opportunity to observe king penguins in the Southern Ocean towards the end of 1773. However, this drawing relates to a later occasion, at the beginning of 1775, when they encountered king penguins in great abundance at South Georgia. It is one of the earliest paintings of the species.

Johann Georg Forster (1754–1794)
HMS *Resolution* 1772–1775
Watercolour on paper
1775
538 x 367 mm

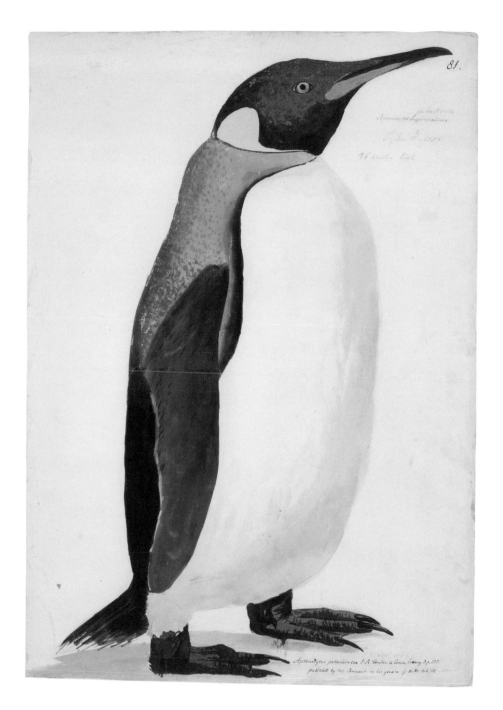

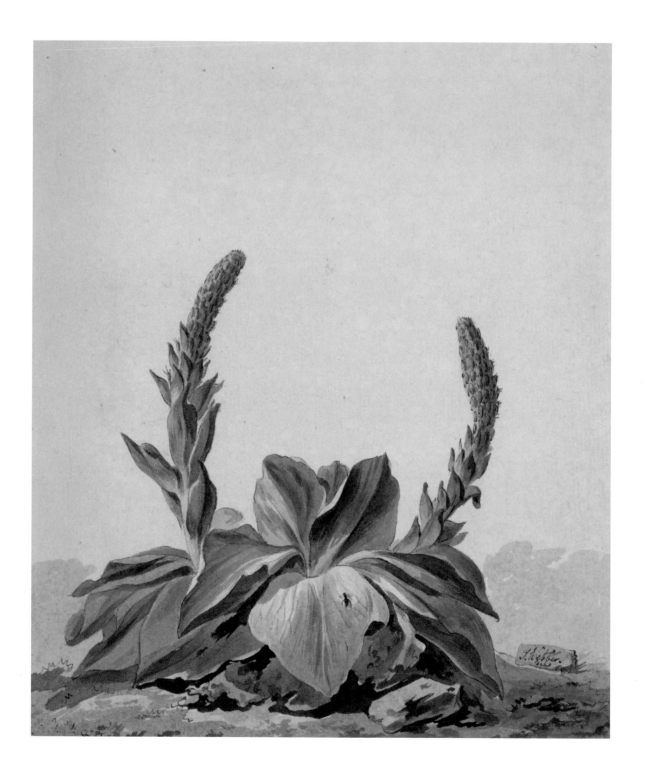

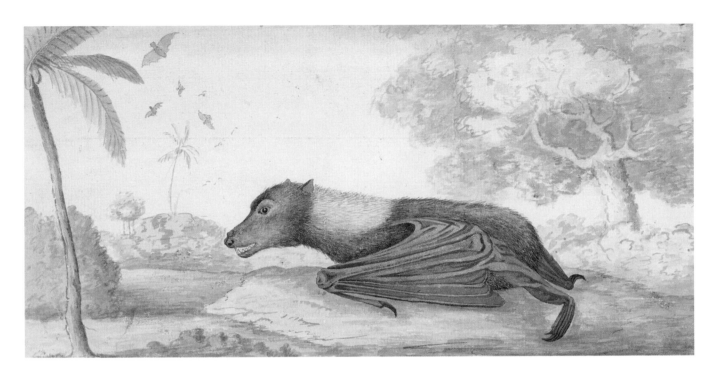

Pringlea antiscorbutica, Kerguelen Island cabbage

This cabbage was first discovered during Captain Cook's third voyage to the Pacific (1776–1780) by Cook's surgeon, William Anderson. Due to the high levels of potassium it contains and the vitamin C-rich oil in its leaves, its consumption greatly helped ships' crews suffering from scurvy.

John Webber (1751–1793)
HMS *Resolution* 1776–1780
Watercolour on paper
*c.*1777
222 x 188 mm

Pteropus sp., flying fox

William Ellis accompanied Captain Cook on his third voyage of discovery to the Pacific (1776–1780) in the capacity of artist. This bat is the most widespread flying fox in the Pacific. It is nocturnal like most species of bat and has a diet of pollen and nectar.

William Ellis (1751–1785)
HMS *Resolution* 1776–1780
Watercolour on paper
*c.*1777
192 x 286 mm

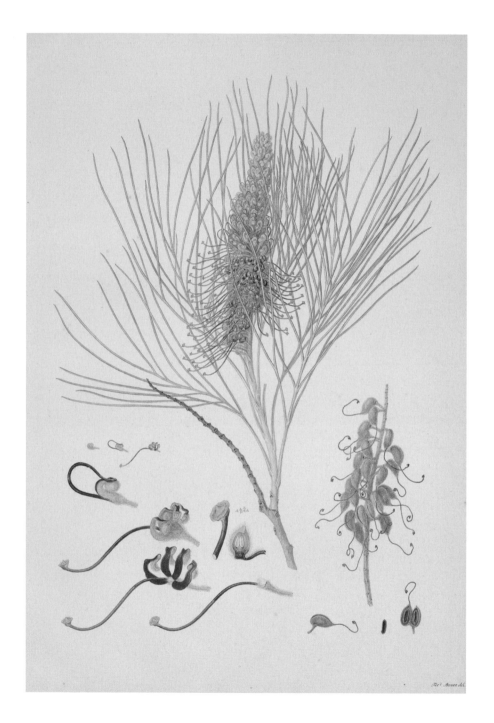

Grevillea pteridifolia, silky grevillea

The shrub *Grevillea pteridifolia* (or silky grevillea, among its number of common names) is found across a wide range of northwestern and northern Australia. Robert Brown collected specimens in the Sir Edward Pellew Group of Islands, Northern Territory, Australia in 1803. After making a detailed pencil drawing in the field, Ferdinand Bauer produced a finished watercolour of the plant following the return of the *Investigator* to England.

Ferdinand Bauer (1760–1826)
Investigator 1801–1803
Watercolour on paper
1805–1814
524 x 355 mm

Gyrostemon ramulosus

The shrub *Gyrostemon ramulosus* was
collected by botanist Robert Brown on
Middle Island, Archipelago of the Recherche,
Western Australia in May 1803. In this
finished watercolour which was made in
London, Ferdinand Bauer painted the three
branches with yellow flowers, young fruits
in the centre and mature fruits to the left.
To further aid identification, he also made
enlarged drawings of the stamens, pollen
grains and seeds.

Ferdinand Bauer (1760–1826)
Investigator 1801–1803
Watercolour on paper
1805–1814
522 x 355 mm

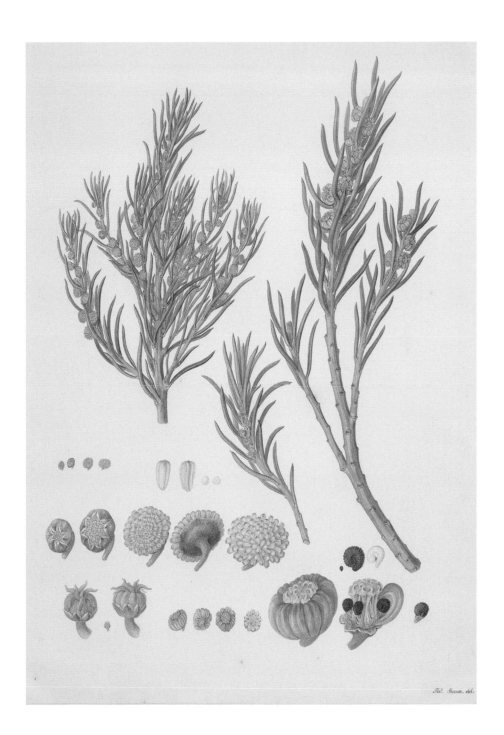

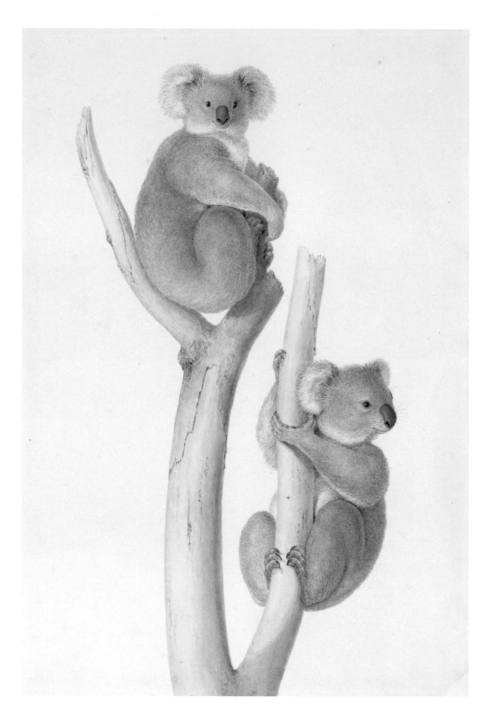

Phascolarctos cinereus, koala

Ferdinand Bauer produced a number of finished watercolours of the koala based on observations in the field and with reference to specimen material brought back to London. The first detailed scientific description of the koala was made by the botanist Robert Brown in 1814.

Ferdinand Bauer (1760–1826)
Investigator 1801–1803
Watercolour on paper
1805–1814
509 x 342 mm

FRONT: *Rhopalostylis sapida*, Norfolk Island palm; BACK: *Araucaria heterophylla*, Norfolk Island pine

Ferdinand Bauer made a small number of pencil drawings of the vegetation of Norfolk Island, off the southeast coast of Australia. Here he depicts Norfolk Island palms in the foreground and pines in the background. During 1804–1805, while repairs were being made to the *Investigator*, Bauer spent time on his own on Norfolk Island, collecting and drawing specimens.

Ferdinand Bauer (1760–1826)
Investigator 1801–1803
Graphite on paper
1804–1805
362 x 262 mm

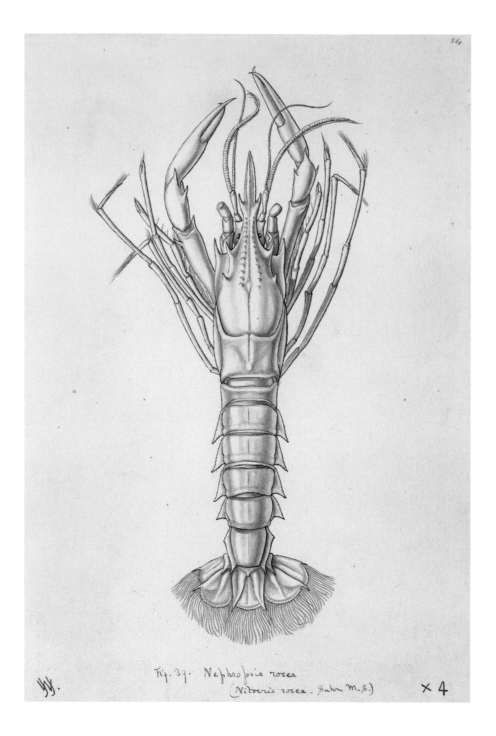

Fig. 39. Nephropsis rosea
(Nitocris rosea. Suhm M.S.)

× 4

Nephropsis rosea, two-toned lobsterette

Swiss-born John James Wild was the official artist and secretary on HMS *Challenger*. His diary is held in the collections along with illustrations such as this two-toned lobsterette. The type specimen was found at the Challenger Station 57, off Bermuda, at a depth of 1,262 m and is held at the Museum, although over time it has completely disintegrated.

John James Wild (1824–1900)
HMS *Challenger* 1872–1876
Pen and ink on paper
*c.*1872–1876
230 x 153 mm

Polycheles enthrix

Rudolph von Willemoes-Suhm was one of the artists on-board the *Challenger* expedition (1872–1876). He died at sea between Hawaii and Tahiti following a short illness. His diary, along with a collection of his sketches, are preserved in the Library. Some of his illustrations were published in Charles Spence Bate's report on the *Macrura of the Challenger Expedition*.

Rudolph von Willemoes-Suhm (1847–1875)
HMS *Challenger* 1872–1876
Ink on paper
*c.*1873–1875
229 x 153 mm

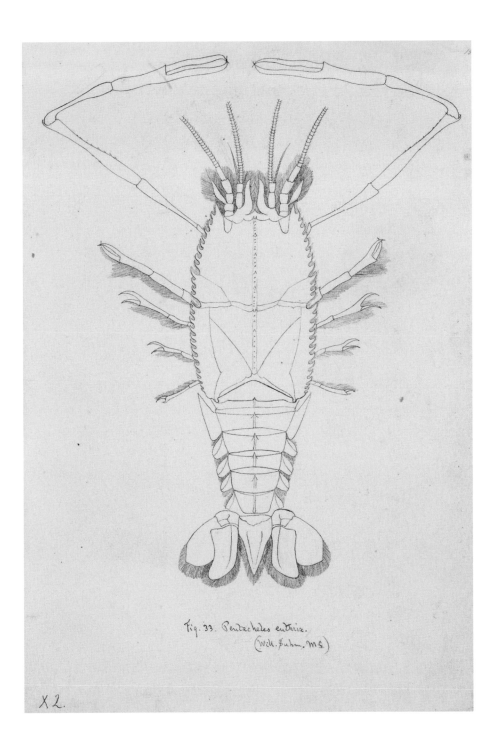

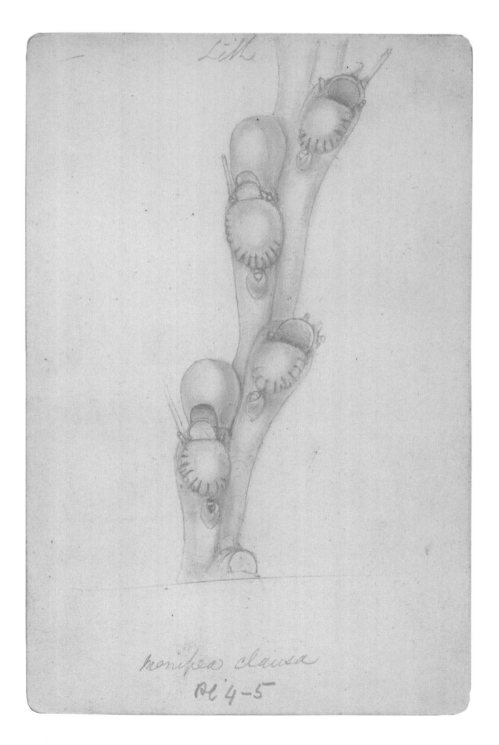

Notoplites clausus

George Busk travelled as naval surgeon on HMS *Grampus* before retiring in 1855 and devoting his time to the study of zoology and palaeontology. An expert on polyzoa, small marine invertebrates, Busk undertook the research on the polyzoa specimens collected during the *Challenger* expedition at the request of Sir Wyville Thomson, the chief scientist of the voyage. The first report on the polyzoa was published in 1884. He described this species as having an 'extremely beautiful form.'

George Busk (1807–1886)
HMS *Challenger* 1872–1876
Graphite on card
*c.*1876–1884

1–7. *Heteromysis* (*Olivemysis*) *bermudensis bermudensis*; 8–23. Ecto- & Ento-parasites of Schizopoda

Norwegian Georg Ossian Sars' first scientific publication was on a species of water flea that he discovered. His primary area of research was fisheries science and in particular crustaceans and their systematics which led to him being appointed to write the report on the Schizopoda collected by *Challenger* Expedition (1872–1876).

Georg Ossian Sars (1837–1927)
HMS *Challenger* 1872–1876
Graphite and ink wash on paper
*c.*1885
278 x 230 mm

Fig. 1-7, Heteromysis bermudensis, n. sp.

8-23, Ecto- & Ento-Parasites of Schizopoda.

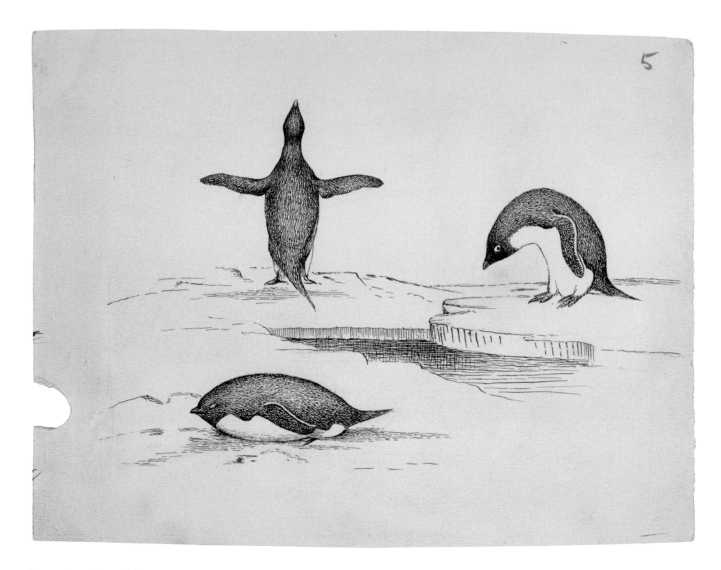

Pygoscelis adeliae, Adélie penguin

A year after qualifying as a doctor in 1900, Edward Adrian Wilson
was to head out to the frozen climes of Antarctica as Junior
Surgeon, vertebrate zoologist and official artist on Captain Scott's
Discovery expedition. A member of the British Ornithologists Union,
Wilson had a keen interest in birds. This pen and ink illustration
captures the mannerisms and charm of the Adélie penguin.

Edward Adrian Wilson (1872–1912)
Discovery 1901–1904
Ink on paper
*c.*1901
148 x 190 mm

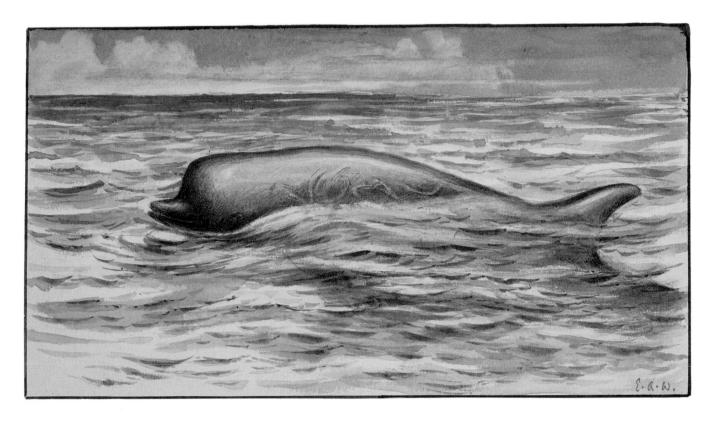

Hyperoodon planifrons, southern bottlenose whale

Edward Adrian Wilson, Captain Scott and Ernest Shackleton set out
on foot to reach the South Pole in November 1902 but had to turn
back, arriving back at camp in February 1903. Despite not making
it, they had travelled the farthest south ever. Wilson painted this
watercolour of a solitary southern bottlenose whale whilst on-
board during the journey out. He returned nine years later when he
did reach the South Pole, but perished in the harsh conditions.

Edward Adrian Wilson (1872–1912)
Discovery 1901–1904
Watercolour on paper
1901
195 x 227 mm

Emperor Penguin No 3.
x circa 3 lam.

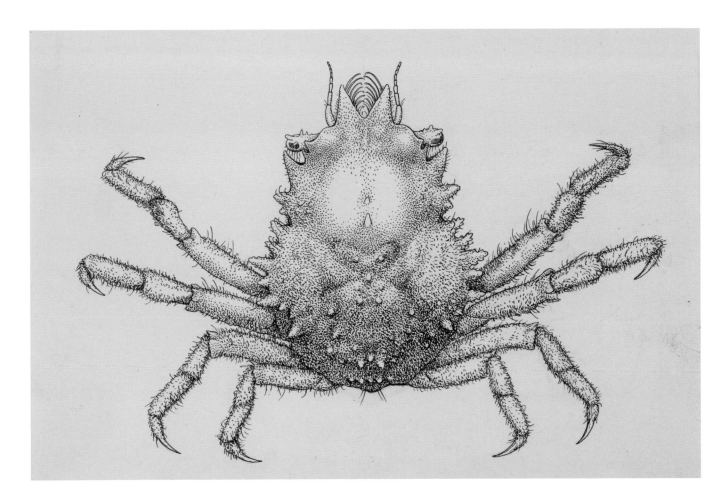

Aptenodytes forsteri, emperor penguin embryo

This graphite illustration of a penguin embryo was drawn by Dorothy Thursby-Pelham from one of the three eggs that were collected from the Cape Crozier rookery during the *Terra Nova* expedition (1910–1913). Thursby-Pelham, a fisheries scientist, worked with embryologist Richard Assheton on analysing the embryos prior to his death in 1915. She also corresponded with Apsley Cherry-Garrard, the assistant zoologist from the expedition.

Dorothy Thursby-Pelham (1884–1972)
Terra Nova 1910–1913
Graphite on paper
*c.*1914–1915
268 x 199 mm

Notomithrax minor, small decorator crab

The decorator crab is so-named because it attaches pieces of seaweed, sponges and other colonial animals to its exoskeleton in an attempt to camouflage itself. Gertrude Mary Woodward completed this pen and ink illustration of the crab without its various decorations for L. A. Borradaile's *Crustacea. Part 1–Decapoda, Natural History Report of the British Antarctic Terra Nova Expedition, 1910* (1916).

Gertrude Mary Woodward (1854–1939)
Terra Nova 1910–1913
Pen and ink on paper
*c.*1916
173 x 240 mm

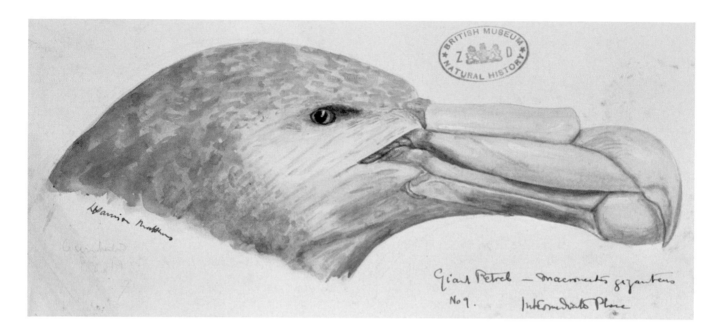

Macronectes giganteus, southern giant petrel

Leonard Harrison Matthews spent five years based on the
sub-Antarctic island of South Georgia, as part of the *Discovery*
investigations that were funded by the British Colonial Office. Although
his volume of 67 illustrations features the heads and feet of South
Georgian birds, his main purpose was the study of marine mammals
and in particular the biology of whales and southern elephant seals.

Leonard Harrison Matthews (1901–1986)
Discovery 1924–1929
Watercolour on paper
*c.*1924–1929
103 x 230 mm

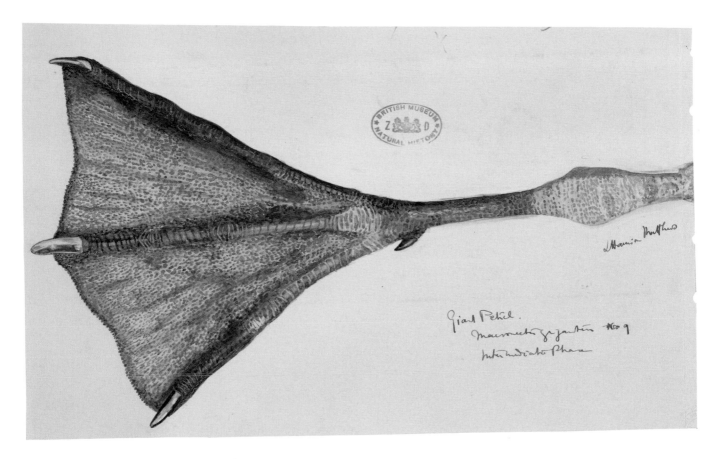

Macronectes giganteus, southern giant petrel

The legs of the southern giant petrel are very strong, which enables them to walk on land effectively and also to attain flight by running across the water surface whilst stiffly beating their wings. Leonard Harrison Matthews writes that he drew his birds from 'Living or freshly killed specimens. All nat. size'.

Leonard Harrison Matthews (1901–1986)
Discovery 1924–1929
Watercolour on paper
*c.*1924–1929
177 x 288 mm

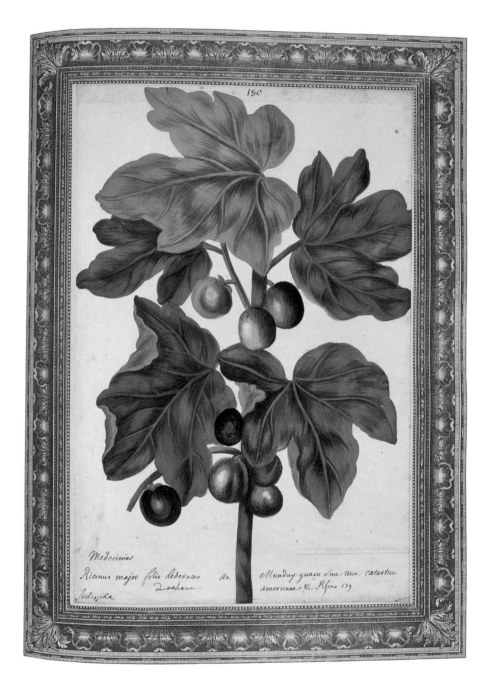

Jatropha curcas, physic nut

The Franciscan monk and botanist Charles Plumier was one of the most important botanical explorers of his time, documenting over 4,300 plants. This illustration is from a collection of 314 illustrations, each with decorative borders. Although the seeds of this plant are unsafe for human consumption, the oil from them is processed for use as biodiesel.

Charles Plumier (1646–1704)
Watercolour on paper
Mid to late seventeenth century
442 x 292 mm

Nepenthes distillatoria, pitcher plant

Paul Hermann travelled to Ceylon in 1672
with the Dutch East India Company as
Medical Officer. During the next five years
he collected and illustrated plants before
returning to Europe as Chair of Botany at
the University of Leiden. His collection of
four herbaria volumes and one of drawings
contained many plants new to science.
Linnaeus studied them, resulting in his
publication *Flora Zeylanica* (1747). This
pitcher plant is the only species of this plant
that occurs in Sri Lanka.

Paul Hermann (1646–1695)
Ink and wash on paper
c. late seventeenth century
527 x 380 mm

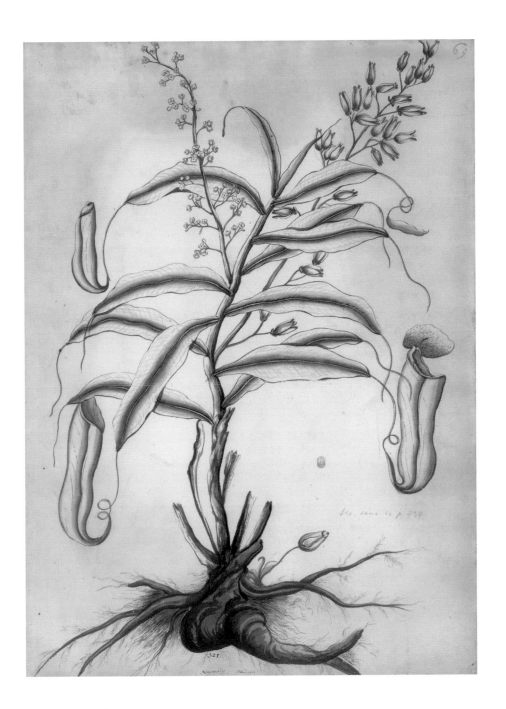

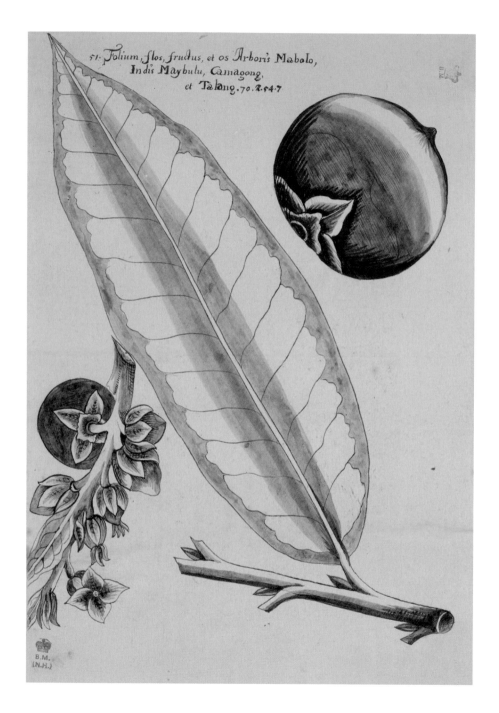

51. Folium, flos, fructus, et os Arboris Mabolo,
Indis Maybulu, Camagong,
et Talang. 70. 2. 54. 7

Diospyros discolor, mabola tree

Georg Joseph Kamel voyaged to the
Philippines as a Jesuit missionary. He arrived
in Manila in 1688 and set up a pharmacy
and established a botanical garden there.
This illustration is from a volume of pen and
ink drawings with manuscript descriptions
entitled *Descriptiones Fructicum et Arborum
Luzonis* which came to the Museum from the
collections of Sir Hans Sloane. The mabola
tree is native to the Philippines where it is an
endangered tree species and protected by
Philippine law.

Georg Joseph Kamel (1661–1706)
Ink and wash on paper
*c.*1700–1701
302 x 209 mm

Monsonia lobata Montin, broad-leaved monsonia

Francis Masson was the first plant hunter to be sent abroad by Kew Gardens to collect plants for their collections. Setting sail aboard James Cook's *Resolution* voyage in 1772, Masson's instructions were to remain and collect specimens at the Cape of Good Hope. He stayed until 1775, during which time he undertook three long expeditions into the interior of southern Africa. The Cape possesses one of the richest and most diverse floras in the world with 9,000 plant species present, 70 per cent of which are not found anywhere else in the world.

Francis Masson (1741–1805)
Watercolour on paper
1775
407 x 272 mm

Tjiapaat

Aeschynanthus sp.

Francisco Noronha was a Spanish physician and naturalist whose travels to the Philippines, Java, Mauritius and Madagascar are little known. This illustration is a copy from Noronha's set of original drawings of Javanese plants that were made for Louis Auguste Deschamps and ordered by the governor of Java. The originals are preserved in the Museum d'Histoire Naturelle in Paris and a further copy is held in Berlin.

Francisco Noronha (1748–1788) drawings collection
Watercolour on paper
Late eighteenth century
315 x 192 mm

Rhinoceros sondaicus, Javan rhinoceros

In 1791, Louis Auguste Deschamps set sail with the Chevalier d'Entrecasteaux on the French frigate *L'Esperance* in search of the ill-fated expedition of Jean-Francois de La Perouse. The expedition failed and Deschamps found himself on Java until 1802, exploring the fauna and flora on behalf of the Governor. His unpublished journals and illustrations are preserved in the Library.

Louis Auguste Deschamps (1765–1842)
Ink wash on paper
c.1793–1802
263 x 365 mm

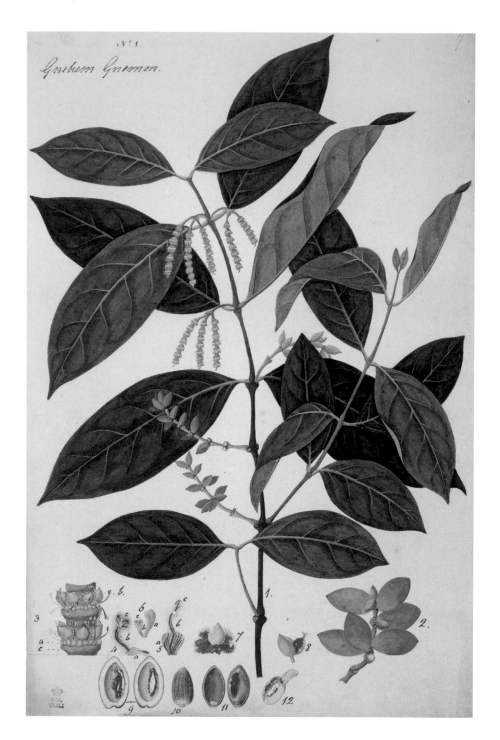

Gnetum gnemon, melindjo

This drawing of *Gnetum gnemon* is from a small collection of Malayan plant drawings assembled by William Roxburgh. It is possible that they were painted locally and then sent to Roxburgh in India. The plant is widely cultivated today in Malaysia and Indonesia for culinary purposes, including as a food preservative. The drawing is accompanied by a Latin manuscript description, including an explanation of the fruit and other parts of the plant figured at the bottom of the drawing.

William Roxburgh (1751–1815) drawings collection
Watercolour on paper
Late eighteenth century
461 x 305 mm

Corypha utan, gebang palm

The drawing of *Corypha utan* is from an album of Indian palms which Roxburgh commissioned for use in the book *Plants of the Coromandel coast*. The artist will have made the very precise, scientific illustration in accordance with Roxburgh's directions, but at the same time it is possible to detect the Mughal artistic tradition of fine attention to detail which is likely to have been part of the unknown artist's training.

William Roxburgh (1751–1815) drawings collection
Watercolour on paper
Late eighteenth century
482 x 346 mm

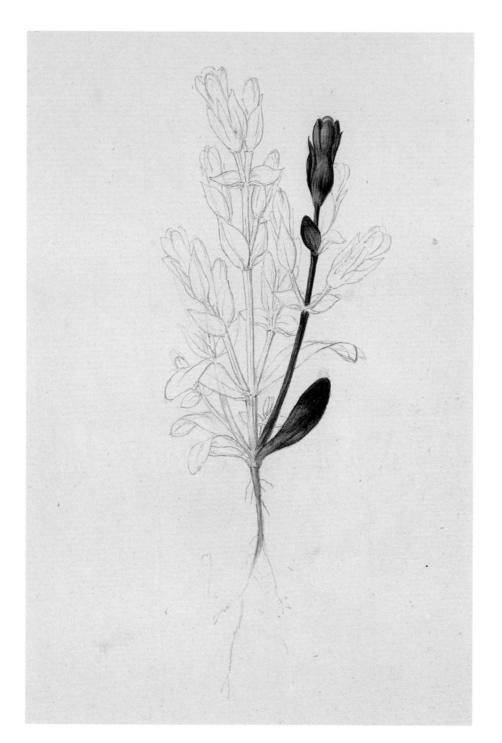

Gentianella campestris, field gentian

John Frederick Miller accompanied Joseph Banks on the first British scientific expedition to Iceland in 1772 as botanical artist. This voyage was to see Banks forge strong friendships with the Icelandic community and he acted as a powerful protector of the Icelandic people and their island during the Napoleonic period.

John Frederick Miller (fl. 1775–1796)
Graphite and watercolour on paper
1772
536 x 366 mm

Gentianella campestris, field gentian

The Icelandic name of this plant is Marivöndur. Thomas Burgis completed the watercolour using the original outline and colour reference previously made by the artist John Frederick Miller, as he did not travel to Iceland himself. Burgis also assisted with the completion of the watercolours of the plants from Cook's *Endeavour* voyage.

Thomas Burgis (fl. 1760 to *c.*1790)
Watercolour on paper
1776
523 x 365 mm

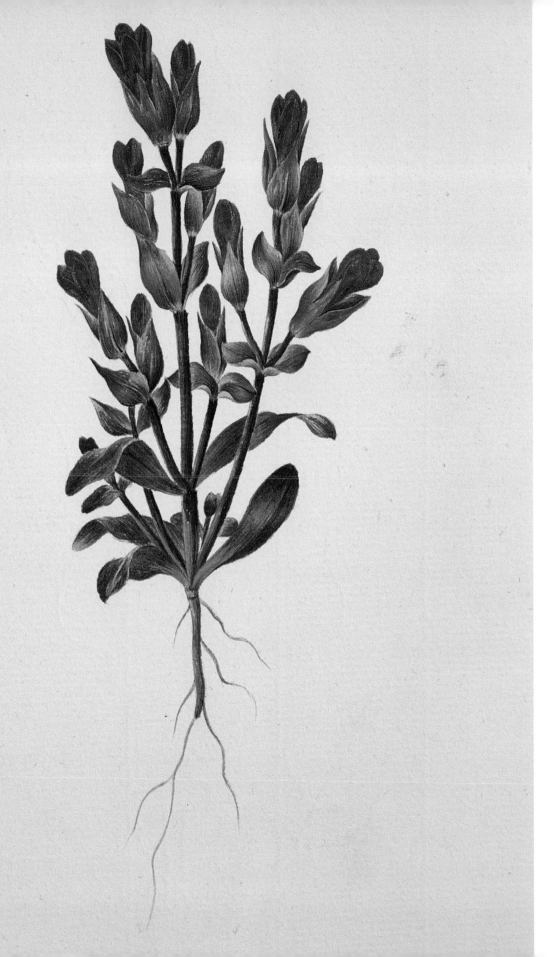

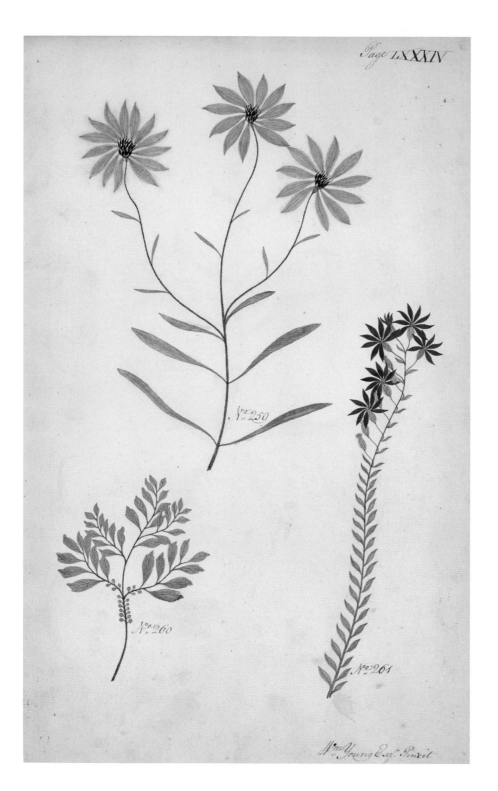

259. *Rudbeckia* sp., black-eyed Susan;
260, 261. unknown

William Young's first voyage from America to England was in 1764, at the request of Queen Charlotte. He was duly appointed Queen's botanist and received botanical instruction from the English botanist John Hill (1714–1775). Young returned to America two years later where he collected and illustrated plants in North and South Carolina.

William Young (1742–1785)
Watercolour on paper
*c.*1766–1768
384 x 238 mm

6. *Aeschynomene americana*, American joint vetch; 7. *Monarda punctata*, spotted beebalm; 8. *Dionaea muscipula*, Venus flytrap

In 1768 William Young returned to England from America with many living plants, including 300 that he had also illustrated in watercolour, albeit quite crudely. He was the first person to successfully transport a living specimen of Venus flytrap (No. 8), which caused a sensation throughout Europe.

William Young (1742–1785)
Watercolour on paper
1767
383 x 235 mm

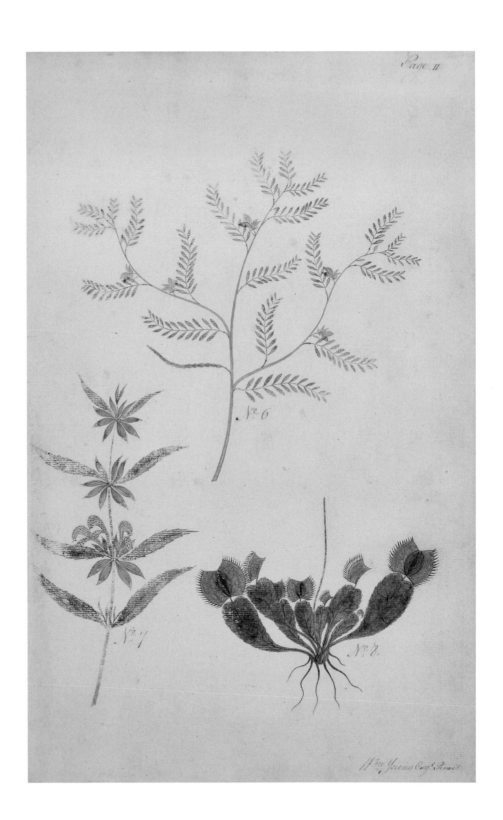

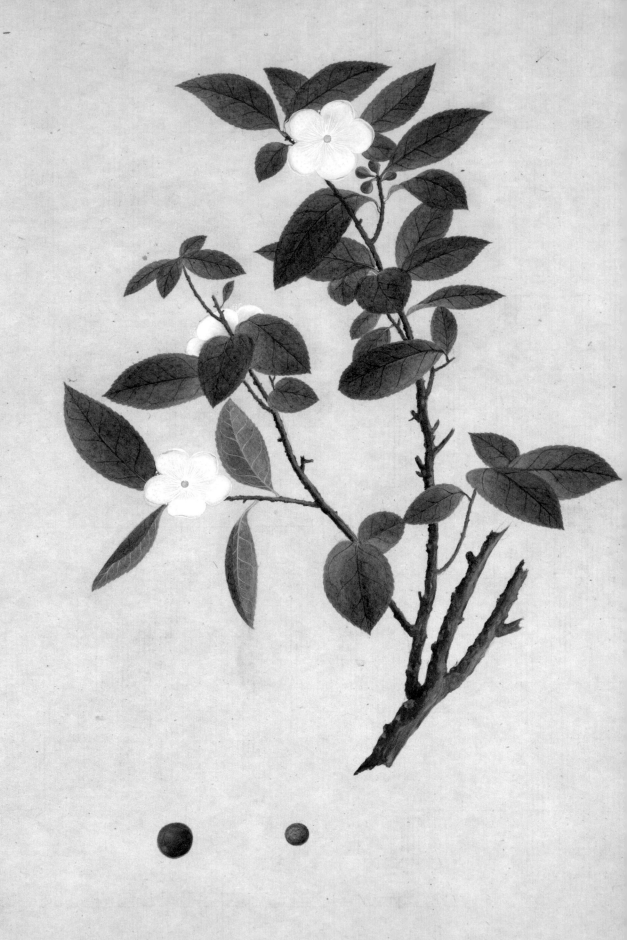

夷
茶 Y
Tcha

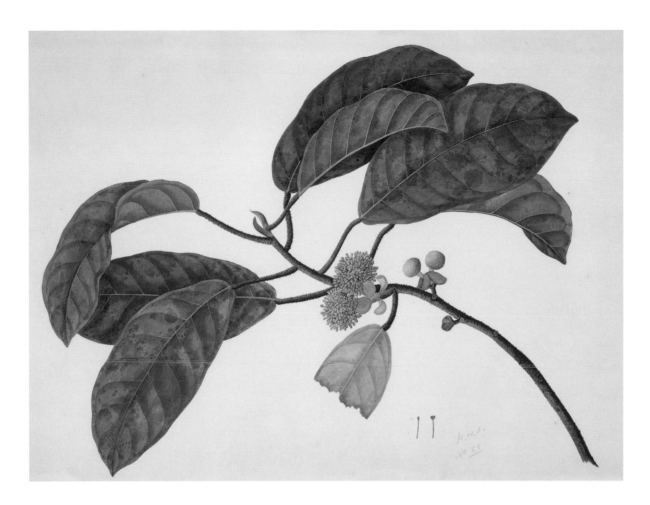

Camellia sinensis, tea

John Bradby Blake travelled to Canton in 1766 in the employment of the British East India Company. He collected seeds of medicinal and economic value to send back to Britain for propagation. This illustration of *Camellia sinensis* is one of the two major varieties of tea grown today and was drawn by a local artist under Blake's supervision.

John Bradby Blake (1745–1773) collection
Watercolour on paper
c.1766–1773
394 x 340 mm

Broussonetia papyrifera, paper mulberry

Broussonetia papyrifera is from a collection of 180 drawings by Christopher Smith of plants from the Straits Settlements (modern day Malaysia). In 1794 Smith was appointed by the British East India Company to establish spice gardens on Penang Island in the Straits and on the Moluccas or Spice Islands, now part of Indonesia. Smith continued in this role until his death in 1806. Nutmeg and cloves were particularly important for trading. The paper mulberry is also a useful plant for food, fibre and medicine. From an early date it was used in paper making in China and Japan.

Christopher Smith (d.1807)
Watercolour on paper
c.1794–1806
470 x 657 mm

Artocarpus altilis, breadfruit

The landscape painter William Westall joined the crew of Matthew Flinders' circumnavigation of Australia on the *Investigator* (1801–1803). Westall's drawing of the breadfruit tree dates from 1806 when he travelled to Jamaica. The breadfruit is an important food source and it was introduced to the West Indies from Tahiti at the instigation of Joseph Banks.

William Westall (1781–1850)
Graphite on paper
1806
227 x 225 mm

Calodendrum capense, Cape chestnut

Clemenz Heinrich Wehdemann, a German soldier, artist and naturalist, arrived at the Cape of Good Hope in the service of the Dutch East India Company in 1784. His volume of 56 watercolour sketches depicts the plants growing around Plettenberg Bay. A native tree to the eastern coast of Africa, the Cape chestnut can grow to heights of 20 metres and is widely cultivated due to its prolific flowers.

Clemenz Heinrich Wehdemann (1762–1835)
Watercolour on paper
*c.*1812
201 x 105 mm

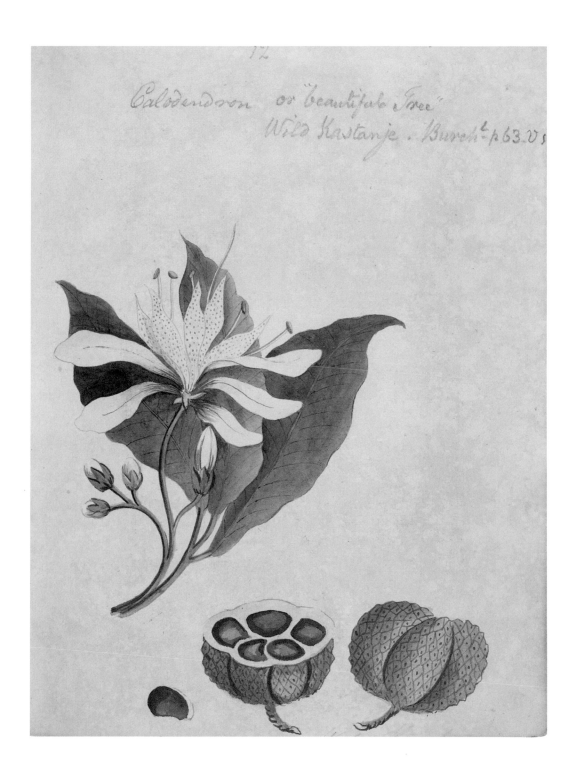

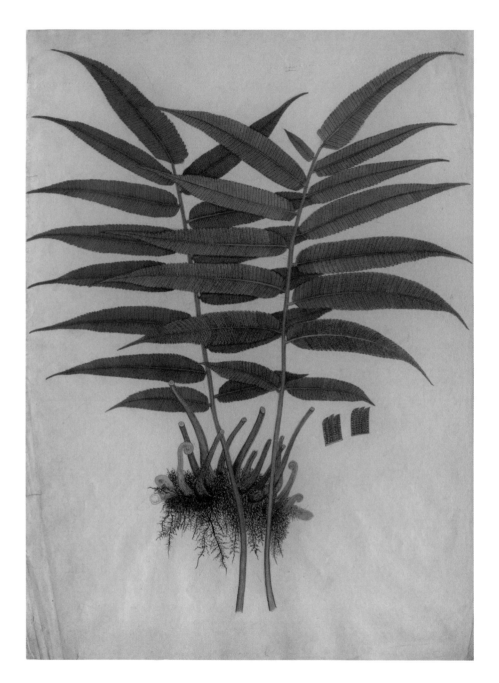

Pronephrium nudatum

Nathaniel Wallich was a Danish physician and botanist who travelled to India between 1817 and 1846. He was the Superintendent of the Calcutta Botanic Garden. A major contributor to plant exploration, he collected plants throughout India, Nepal, Singapore, Penang and the Cape. He also assisted other plant hunters and amassed a large collection of botanical drawings undertaken by Indian artists.

Nathaniel Wallich (1786–1854)
Watercolour on paper
c.1820s
486 x 343 mm

Barringtonia acutangula

Robert Wight first travelled to India in 1819 in the British East India Company's service and his interest in botany saw him eventually appointed to naturalist of the Company in 1826. He employed native artists to illustrate his extensive botanical collections – over 100,000 specimens representing 4,000 species – which are now held at Kew. This illustration is by one of his favourite artists, Rungiah, and is from a collection of 740 watercolours of Indian plants.

Rungiah
Watercolour and ink over pencil on paper
c.1825–1830
198 x 160 mm

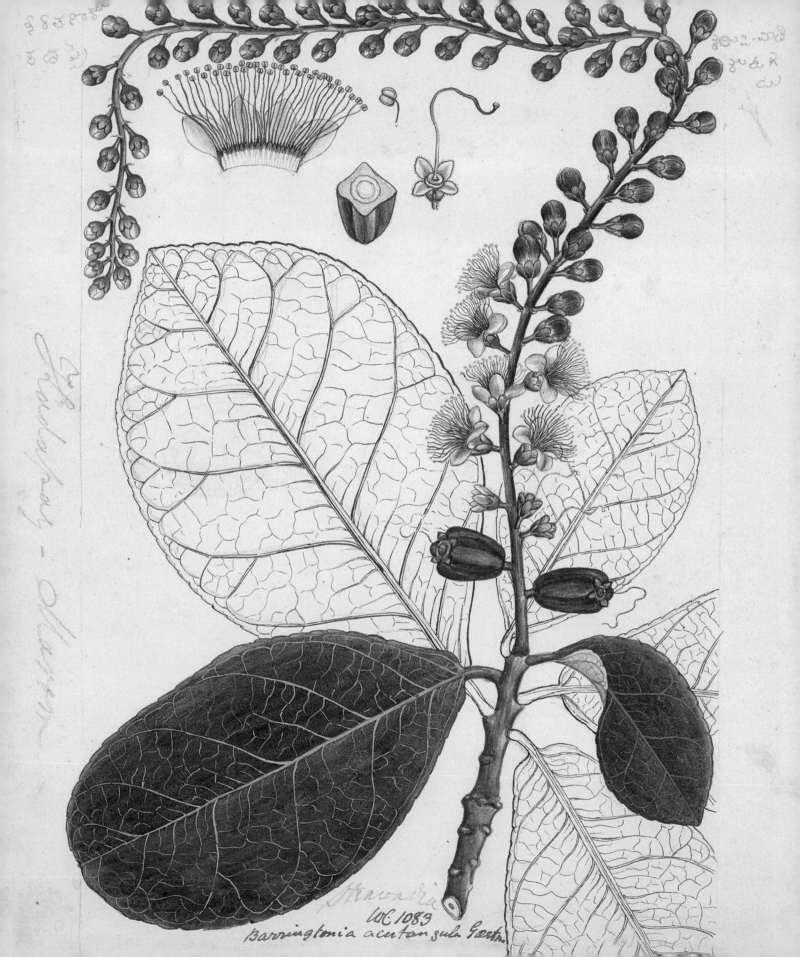

WC 1083
Barringtonia acutangula Gærtn.

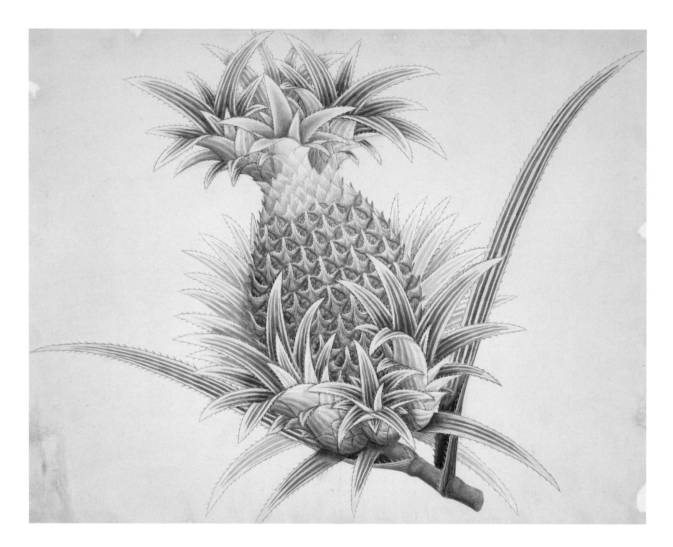

Ananas comosus, pineapple

John Reeves, naturalist and inspector of tea for the British East India
Company at Canton in the early nineteenth century, commissioned
drawings of cultivated flowers and fruits as well as wild plants. The
pineapple was originally grown in South America and from there
Portuguese travellers introduced it to Goa in India and then to China.
In the seventeenth and eighteenth centuries it became fashionable
for wealthy landowners in England to grow pineapples in heated
glasshouses.

John Reeves (1774–1856) drawings collection
Watercolour on paper
Early nineteenth century
488 x 395 mm

Paphiopedilum lawrenceanum,
Lawrence's paphiopedilum

Frederick William Burbidge worked at Kew Gardens prior to travelling to Borneo in 1877 to collect plants for the Veitch nurseries in London. This orchid is endemic to Borneo and the only species found on Mount Kinabalu. It has become so rare it is now classed as Critically Endangered.

Frederick William Burbidge (1847–1905)
Watercolour on paper
1877
240 x 146 mm

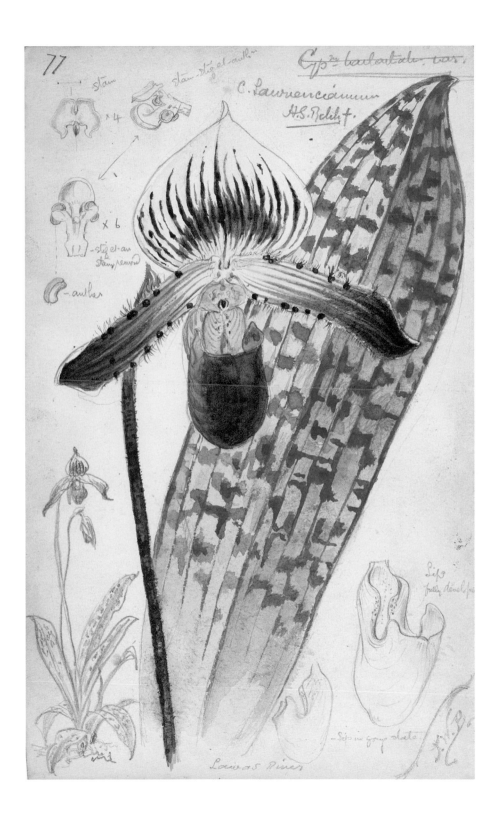

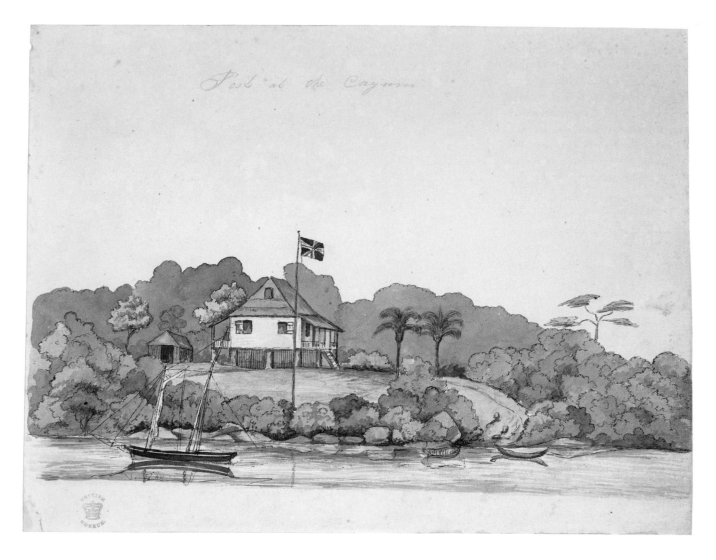

Post at the Cayuni

Sketch of the post house on the Cayuni River

German-born explorer Robert Hermann Schomburgk, travelled to the island of Anegada, one of the British Virgin Islands, which he surveyed at his own expense. This led to him receiving instruction from the Royal Geographical Society to explore British Guiana between 1835 and 1839. This illustration is of the post house on the Cayuni River which matches a description in Schomburgk's report during his first expedition between 1835–1836.

Robert Hermann Schomburgk (1804–1865) drawings collection
Watercolour on paper
c.1835–1844
227 x 270 mm

Pouteria caimito, abiu

Robert Hermann Schomburgk successfully undertook three separate journeys in the interior of Guiana between 1835 and 1839 where he discovered many new plant species. He returned there between 1841 and 1844 during which time he delineated the boundary between British Guiana and Venezuela which became known as the Schomburgk Line. In 1847 he presented a series of watercolour drawings of the plants to the Museum along with 2,341 plant specimens at various dates from 1836.

Robert Hermann Schomburgk (1804–1865) drawings collection
Watercolour on paper
c.1835–1844
365 x 265 mm

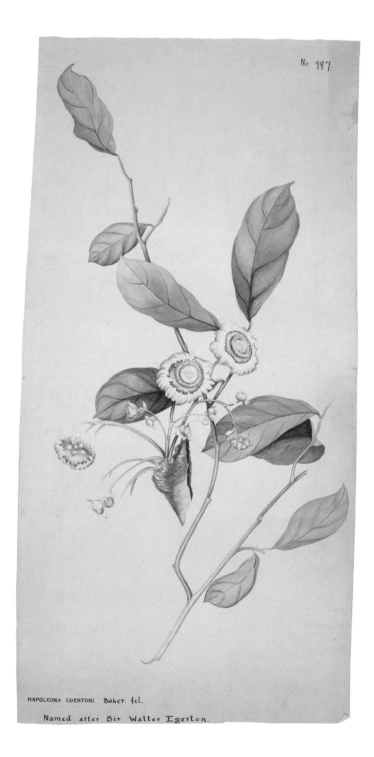

Napoleonaea egertonii

Dorothy Talbot travelled to southern Nigeria
with her husband Percy in 1909 following
his appointment as a colonial district officer.
Together they collected plants which she
went on to illustrate. Their plant collections
now form part of the Museum's Herbarium
collections along with nearly 600 of her
drawings.

Dorothy Talbot (1871–1916)
Watercolour on paper
c.1909–1912
705 x 345 mm

Bromelia antiacantha

Margaret Mee first travelled to Brazil in 1952
with her husband Greville Mee. There she
explored, studied and painted the living
plants that she found, some of which were
new to science. She actively campaigned to
highlight the deforestation of the Amazon
region, and the Margaret Mee Amazon Trust
was established in her memory.

Margaret Mee (1909–1988)
Watercolour on paper
1958
660 x 480 mm

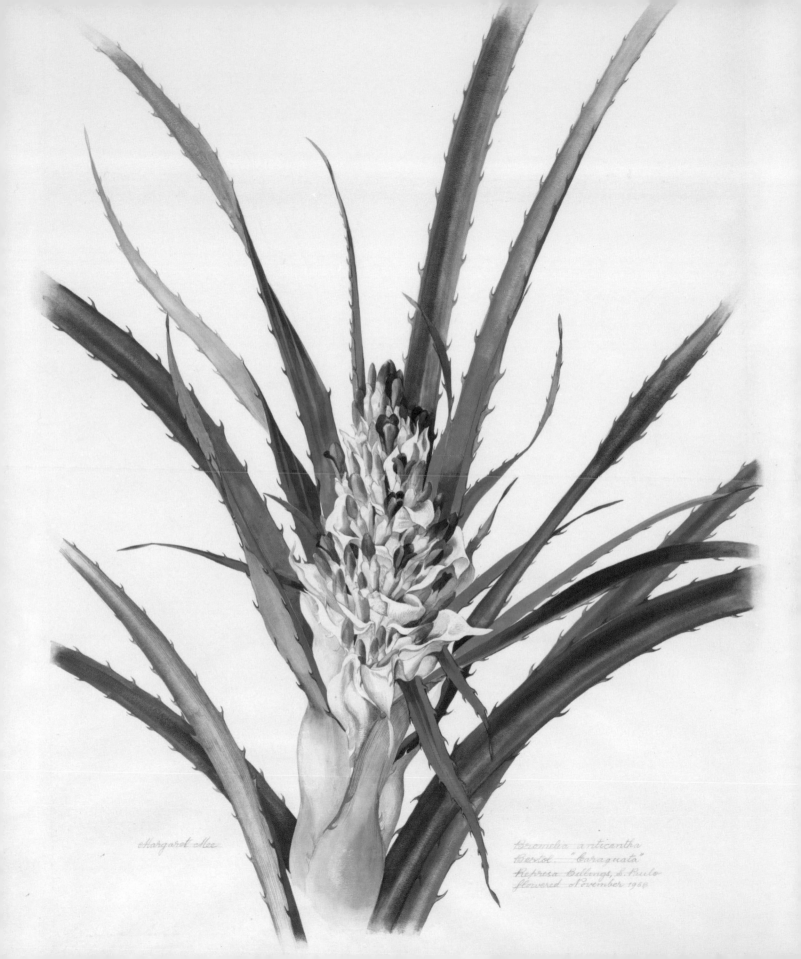

Margaret Mee

Bromelia anticantha
Bertol. "Caraguata"
Represa Billings, S. Paulo
flowered November 1958

Batrachostomus
Podargus moniliger (Lazard).
Hab. Ceylon.—

Batrachostomus moniliger, Sri Lanka frogmouth

Found in the Western Ghats of southwest India and Sri Lanka, the Sri Lanka frogmouth has, like other frogmouths, a wide bill and a large head with forward-facing eyes that provide a wide field of binocular vision. Robert Christopher Tytler travelled to India in 1835 and joined his father's infantry in the East India's Bengal Army. He was to become an expert on Indian birds and had the Tytler's leaf-warbler named after him.

Robert Christopher Tytler (1818–1872)
Watercolour on paper
*c.*1840–1860
375 x 282 mm

Tringa nebularia, common greenshank

Samuel Richard Tickell made this drawing of the common greenshank on the mudflats of an Indian river when the bird was in its winter plumage. It is a migratory species and breeds in northern Europe and Asia. Tickell was born in India where his father was a Lieutenant-General in the Bengal Engineers. He followed in his father's footsteps, rising to the rank of Colonel, and his military travels enabled him to make field observations and collect specimens across India. He published many journal papers based on his natural history studies.

Samuel Richard Tickell (1811–1875)
Watercolour on paper
*c.*1848
225 x 178 mm

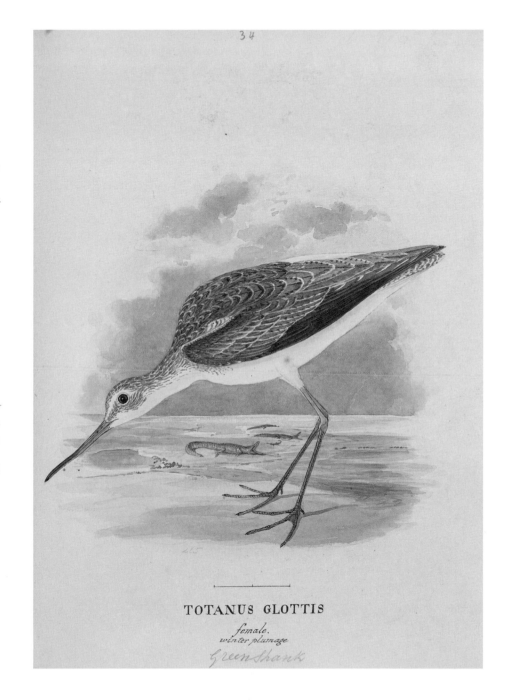

TOTANUS GLOTTIS
female.
winter plumage
Greenshank

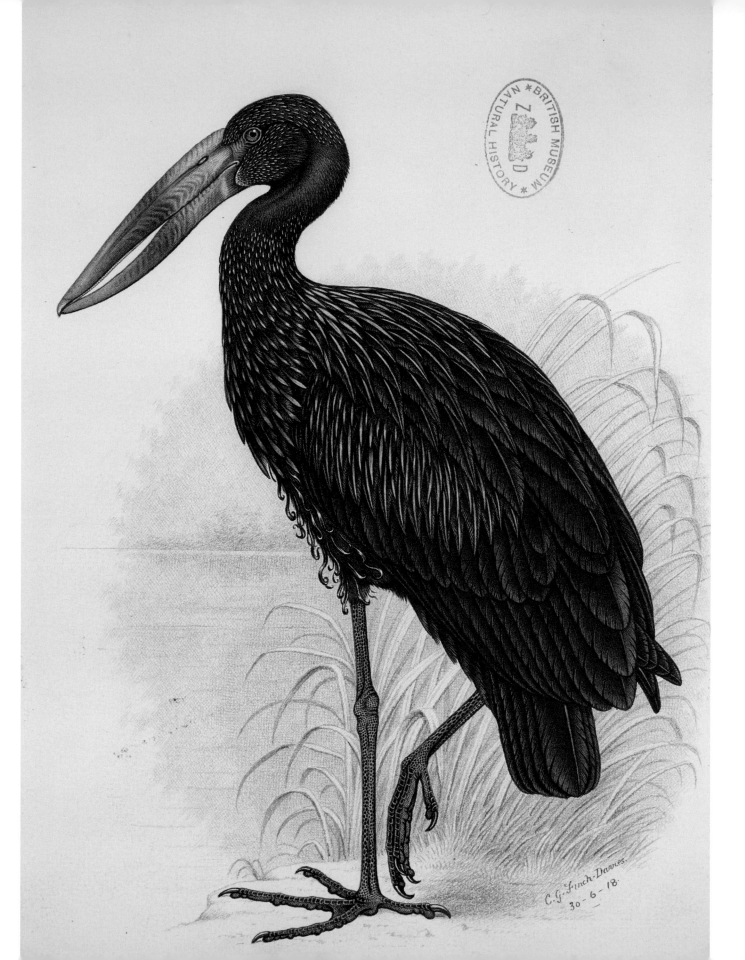

C.G.Finch-Davies.
30-6-18.

Anastomus lamelligerus, African
open-billed stork

Claude Gibney Finch-Davies first travelled to
South Africa in 1893 as a professional soldier
and it was there he developed an interest in
natural history and, in particular, birds. The
African open-billed stork, which Finch-Davies
masterfully depicted, is a non-migratory bird
found throughout sub-Saharan Africa.

Claude Gibney Finch-Davies (1874–1920)
Watercolour on paper
1918
256 x 177 mm

Quiscalus major, boat-tailed grackle

John Abbot produced several thousand
illustrations of insects and many hundreds
of birds during his lifetime in Georgia.
Despite the magnitude of his output, he only
published one book, *The Natural History of
the Rarer Lepidopterous Insects of Georgia*,
in 1797.

John Abbot (1751–*c*.1840)
Watercolour on paper
1827
307 x 197 mm

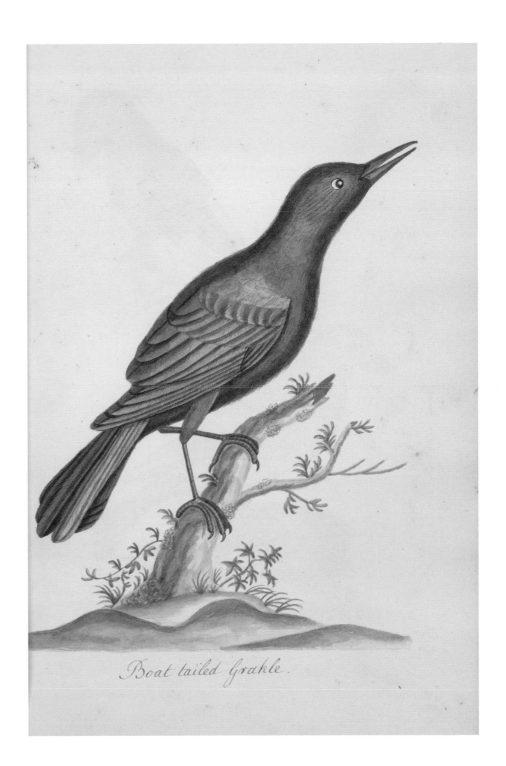

Boat tailed Grakle.

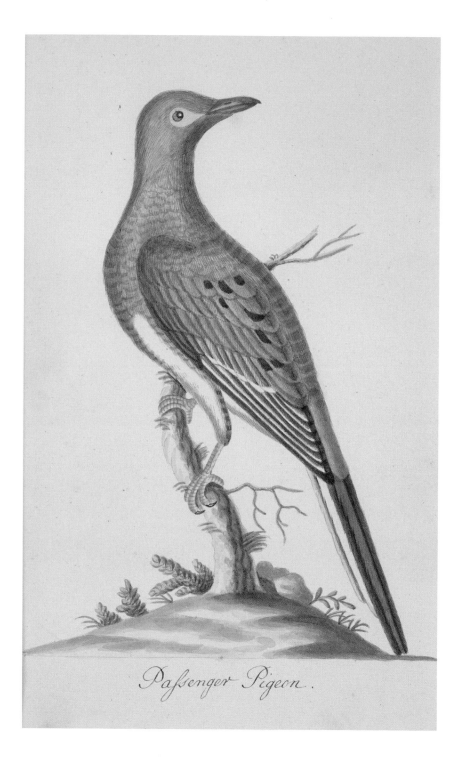

Passenger Pigeon.

Ectopistes migratorius, passenger pigeon

During John Abbot's time, the passenger pigeon would have been the most abundant bird in North America. The species became extinct in 1914 when the last female of the species died in Cincinnati Zoo. Hunted out of existence, their demise brought about the nation's first wildlife-protection law in 1900.

John Abbot (1751–c.1840)
Watercolour on paper
1827
307 x 197 mm

Dynastes tityus, eastern Hercules beetle

The eastern Hercules beetle gets its name from the two large horns found on the male – the female is hornless. A species of rhinoceros beetle, it is one of the largest and heaviest beetles found in the eastern United States. They are primarily nocturnal and harmless to humans.

John Abbot (1751–c.1840)
Watercolour on paper
c.1792
234 x 167 mm

19.

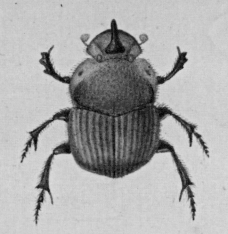

21.

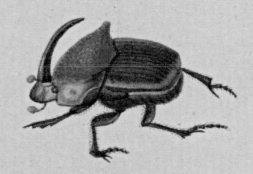

20.

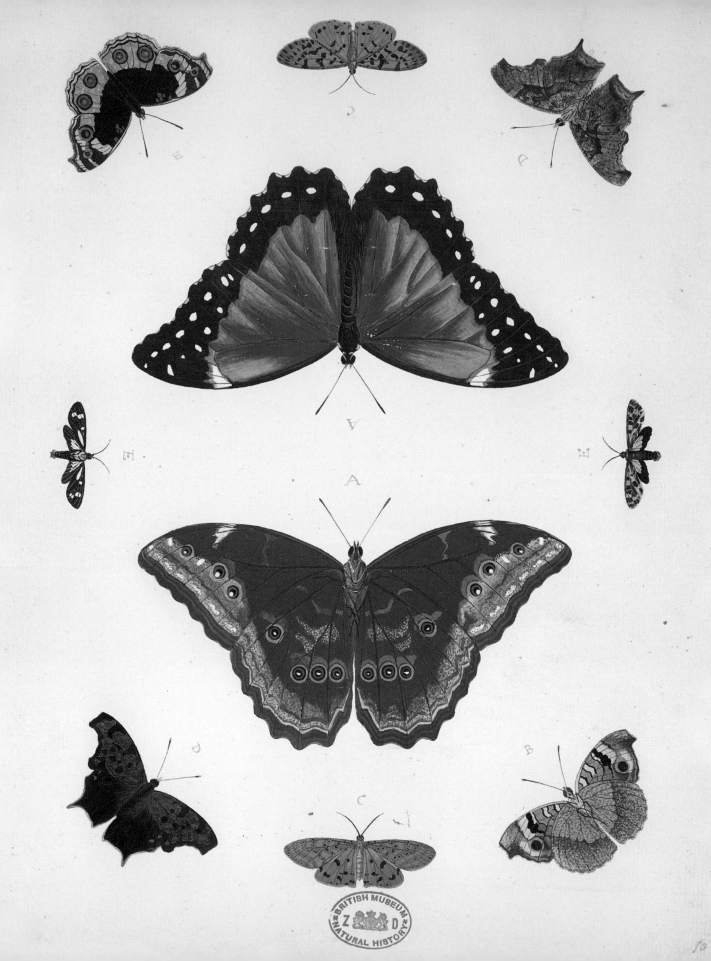

AA. *Morpho menelaus*, blue morpho; BB. *Junonia orithya*, blue pansy or eyed pansy; CC. *Mangina syringa*, tiger moth; DD. *Polygonia interrogationis*; EE. *Heliura marica*, tiger moth

Despite the Dutch merchant Pieter Cramer not travelling himself, he amassed an extensive natural history collection through his trading links and commissioned the Dutch painter Gerrit Wartenaar Lambertz to illustrate his butterfly collection. With over 1,650 butterfly species depicted, many new to science, it became the first coloured printed book to arrange exotic butterflies in accordance with the Linnean system of classification.

Pieter Cramer (1721–1776)
Watercolour on paper
c.1770s
372 x 264 mm

439. *Menander hebrus*; 143. *Menander menander*; 143a. *Menander menander*; 440. *Periplacis glaucoma*; 285. *Lasaia agesilas*; 145. *Adelotypa* sp.

Henry Walter Bates filled his notebooks with careful observations and illustrations of his explorations. He collected and sold specimens to dealers in Europe to fund his travels. He is estimated to have collected over 14,000 insect species of which 8,000 were new to science.

Henry Walter Bates (1825–1892)
Watercolour on paper
1851–1859
176 x 95 mm

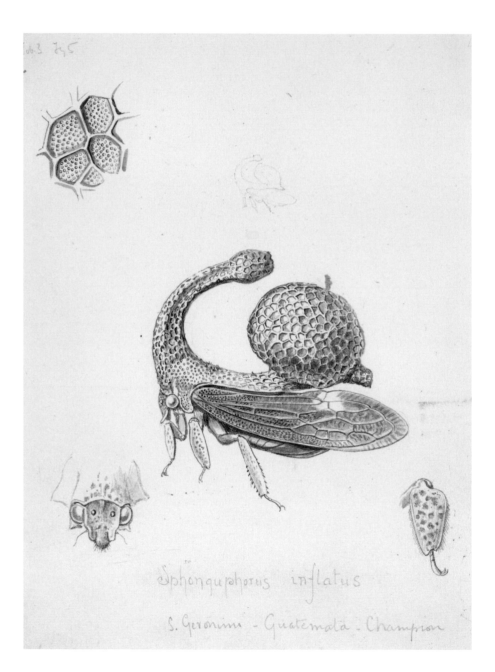

Sphonguphorus inflatus

S. Geronimi - Guatemala - Champion

Cladonata inflatus, tree hopper

Frederick Du Cane Godman and Osbert Salvin were the editors of an enormous publishing endeavour, *Biologia Centrali-Americana*. Between 1879 and 1915, 63 volumes were published and it became the most comprehensive study of Central American wildlife. Both Godman and Salvin travelled extensively in Central America, amassing specimens for their own collections which they then employed artists to illustrate. Edwin Wilson provided illustrations for many of the insect volumes which included this species of tree hopper.

Edwin Wilson (1855–1915)
Ink and wash on paper
*c.*1870–1880
140 x 117 mm

1. *Troides darsius*, common birdwing;
2. *Papilio polymnestor*, blue Mormon;
3. *Papilio polytes romulus*, common Mormon; 4. *Papilio demoleus*, common lime; 5. *Papilio polytes*, common Mormon;
6. *Papilio clytia*, common mime

Edgar Leopold Layard joined the Ceylon Civil Service in 1846 where he served for nine years before moving to South Africa with his wife due to their ill health. These illustrations of Lepidoptera depict the butterflies in their larva and pupa stages.

Edgar Leopold Layard (1824–1900)
Watercolour on paper
*c.*1844
301 x 210 mm

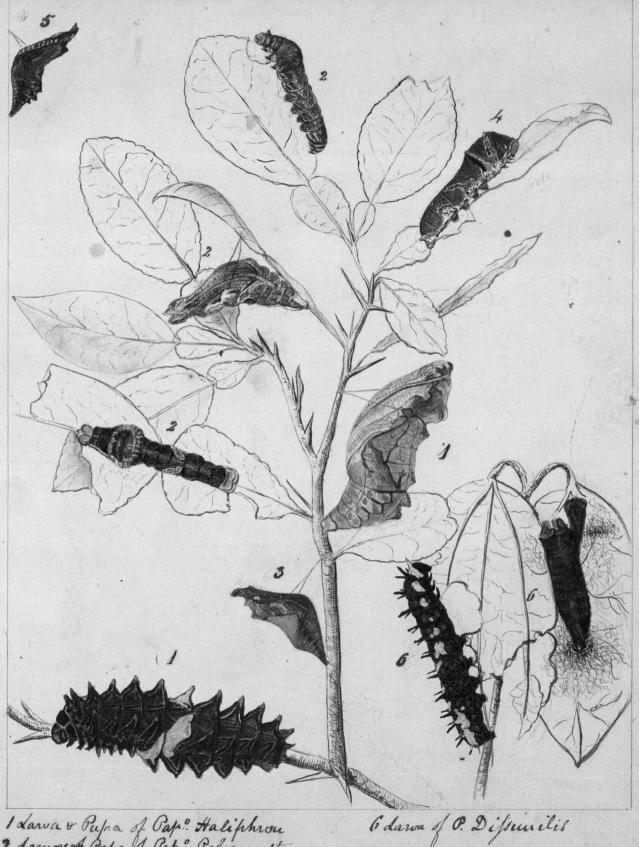

1 Larva & Pupa of Pap.ᵒ Haliphron 6 Larva of P. Dissimilis

2 Larvæ & Pupa of Pap.ᵒ Polymnestor

3 Pupa of Pap.ᵒ Mutius

4 Larva of P. Spius Erithonius

5 Larva of P. Paimnon

1039 1 <u>Tikal</u>, Peten : Phalangium

1040 2 Same loc, 1 same as N° 1075 and another Jumper

1041 6 Same loc, large groundspiders, all different

1042 5 Same loc, smaller do

1043 1 Tikal ... C Thorax very dark
chocolate brown, very deeply indented
at back of head, other indentations
radiate from this towards margin. In
these indentations dirty olive green hair.
Eyes on a raised socket, glassy, between
middle pair a large tuft of hair. Round base of
palces reddish hair; on palces rows of strong
bristles. Legs dirty greyish brown (palpi same)
set with longitudinal rows of long brown
bristles & hair. Abd apparently
black, thickly cov.d with black
& red hair & bristles, underneath
shorter black hair. Sternum &
first joints of legs very thickly
furred w. olive brown hair. With
cocoon. —

Nat. sz

1044 10 <u>Menché</u>, Usumacinta, same as N° 75

1045 1 Same loc, same as N° 1014

1046 1 Same loc, same as N° 1075

1047 7 Same loc, same as N° 492

1048 4 Same loc, same as N° 314 (perhaps 2 species ?)

1049 1 Same loc. This is allied to N° 475, but a different
species. C. Thorax shiny olive brown, legs do, hairless.
Cephalic portion well defined, paler, more reddish in colour.
Abd. very much depressed, horny, terminating in 2 long
spines of a liver-brown. 2 large upright spinous pro-
-cesses just above & in front of spinners. Colour deep
reddish brown, with markings of Naples yellow, shiny, corrugated.

1050 1 Same loc, same as N° 241

Citharacanthus longipes, tarantula; *Micrathena brevipes*

Francis Charles Anthony Sarg was the first German resident of Alta Verapaz in Guatemala, Central America. He collected and contributed illustrations of Araneida (spiders) for Godman and Salvin's publishing endeavour *Biologia Centralia-Americana*, beautifully recording his observations in this notebook.

Francis Charles Anthony Sarg (*c*.1840–1915)
Watercolour on paper
1881
228 x 182 mm

Phoebis sennae, cloudless sulphur on *Cassia emarginata*, yellow candle wood

Born in Ireland, Edith Blake travelled widely with her husband Henry Blake, including to Jamaica where he was Governor from 1889 to 1897. She spent her time observing and painting from nature, including this cloudless sulphur butterfly which she witnessed in all stages of its development. It is shown here with the plant upon which it was found.

Edith Blake (1845–1926)
Watercolour on paper
1893
299 x 238 mm

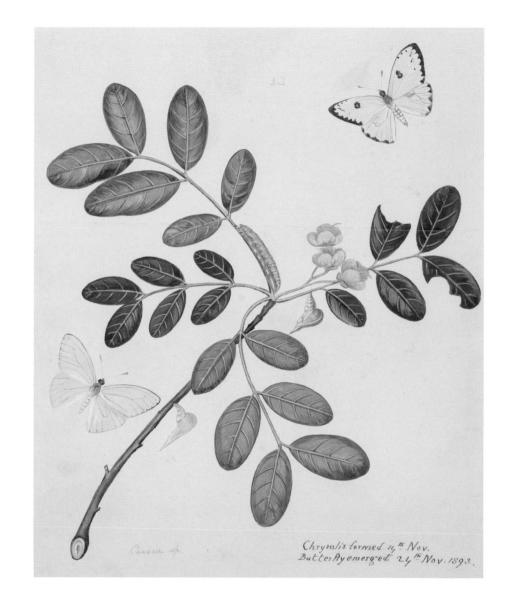

Cassia sp.

Chrysalis formed 14th Nov.
Butterfly emerged 24th Nov. 1893.

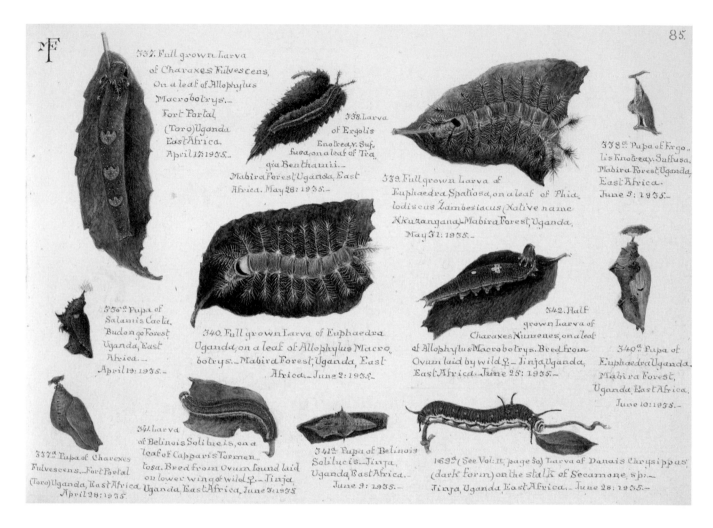

337. *Charaxes fulvescens*, forest pearl charaxes; 338, 338a.
Ariadne enotrea, African castor; 339. *Euphaedra harpalyce*
common blue-banded forester; 336a, 337a. *Salamis cacta*, lilac
mother-of-pearl or lilac beauty; 340, 340a. *Euphaedra* sp.; 342.
Charaxes numenes, lesser blue charaxes; 341, 341a. *Belenois
solilucis*, yellow caper white; 169a. *Danaus chrysippus*, plain tiger

Margaret Fountaine was an adventurous traveller and collector
who amassed a collection of 22,000 butterflies with her partner
Khalil Neimy. She also fastidiously recorded her life experiences
and observations from her extensive travels in her diaries. These
illustrations are from one of four sketchbooks that detail the larval
and pupal stages of the butterflies she observed on her travels.

Margaret Fountaine (1862–1940)
Watercolour on paper
1931–1939
178 x 249 mm

Balaena mysticetus, bowhead whale

These depictions of the bowhead whale are the earliest known
drawings of a whale in the Library's collections. These whales live
entirely in the Arctic and sub-Arctic waters and can weigh up to 100
tonnes. Highly vocal, they are known to be among the longest-living
mammals, with some living as long as 200 years.

Sigismund Bacstrom (c.1750–1805)
Watercolour on paper
1786
337 x 250 mm

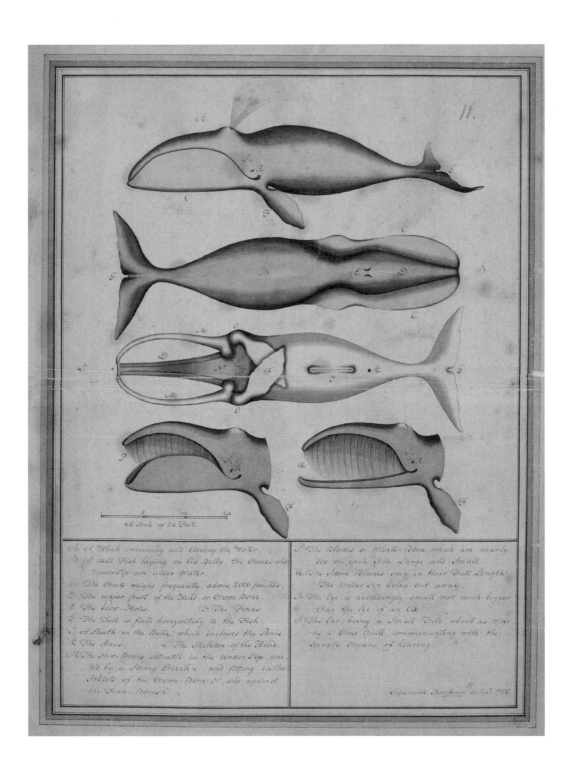

Arctonyx collaris, hog badger

Thomas Hardwicke combined a military career in India with collecting
natural history specimens and drawings. The eminent British
zoologist John Edward Gray noted that the drawings 'were made
upon the spot and chiefly from living specimens of animals'. This
drawing is unusual among the Hardwicke collection for having a fully
painted background. The hog badger is nocturnal and its snout helps
it to root for animal and plant foods.

Thomas Hardwicke (1755–1835)
Watercolour on paper
*c.*1790–1835
220 x 282 mm

Prionodon linsang, banded linsang

The banded linsang, with its razor sharp teeth and retractable claws, is a nocturnal, solitary tree-dweller that is native to Southeast Asia. Their long bodies, short legs and long necks give them a most distinctive appearance, along with their tails that are almost as long as the head and body.

Thomas Hardwicke (1755–1835)
Watercolour on paper
*c.*1790–1835
246 x 383 mm

Ratufa bicolor, black giant squirrel

This large tree squirrel is part of a larger collection of drawings
undertaken by local Nepalese artists that Bryan Houghton Hodgson
employed. Hodgson travelled to India at the age of 17 with the
British East India Company but ill health saw him move to Nepal
where he was the first British Resident. Using local trappers, he
amassed a large collection of bird and mammal skins, many of which
had not previously been described.

Bryan Houghton Hodgson (1800–1894) drawings collection
Watercolour on paper
1845–1858
280 x 473 mm

Viverra sp., civet

William Henry Sykes was employed as a statistical reporter to the Bombay government and carried out a survey of the Deccan between 1824 and 1831. Sykes's draughtsman, Bombardier Llewellyn Fidlor, made highly detailed drawings of agricultural scenes as well as wild plants and animals. In this image Fidlor has drawn a civet, well known for its highly scented secretion.

Llewellyn Fidlor (fl. 1820s)
Watercolour on paper
1827
232 x 312 mm

Diceros bicornis, black rhinoceros

The population of the black rhinoceros has declined by an estimated
97.6 per cent since 1960 and it is now regarded as Critically
Endangered. At the time of this watercolour, it would have been the
most numerous of the world's rhino species but relentless hunting
and poaching have completely decimated its numbers.

William Cornwallis Harris (1807–1848)
Watercolour on paper
1836–1837
218 x 276 mm

Tragelaphus strepsiceros, greater kudu

The greater kudu remains a much sought after hunting trophy animal due to the adult male's magnificent horns, as well as for its meat. Herbivorous in their diet, they are the tallest of the antelopes and are able to run very fast to evade predators.

William Cornwallis Harris (1807–1848)
Watercolour on paper
1836–1837
220 x 275 mm

Bos taurus, cattle

Johann Martin Bernatz was the official artist for the British expedition
led by Captain William Cornwallis Harris to Ethiopia (1841–1843).
The Bernatz drawing collection comprises 104 drawings, mostly
watercolour and graphite, along with some sketches that depict the
landscapes he observed.

Johann Martin Bernatz (1802–1878)
Watercolour on graphite on paper
1841–1844
272 x 389 mm

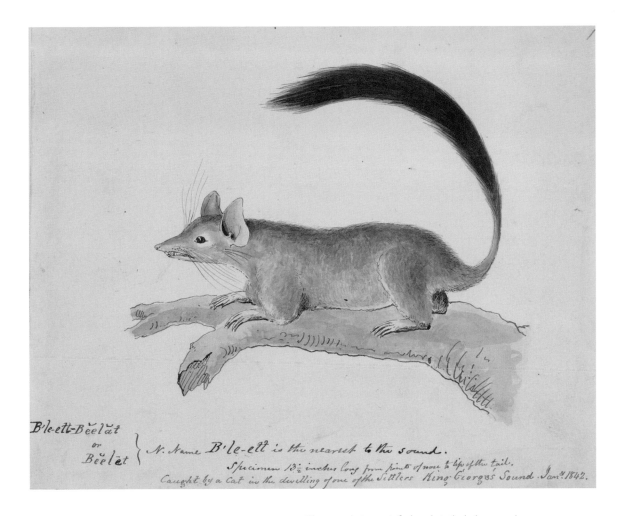

Phascogale tapoatafa, brush-tailed phascogale

Robert Neill and his family emigrated to Van Diemen's Land
(Tasmania) from Scotland in 1820. He developed an interest in
natural history and would send the specimens he collected back
to his home town, Edinburgh. This illustration is from a volume of
drawings of Western Australian mammals, reptiles and fish. The males
of this species of phascogale have short lives, typically one year, as
they die shortly after mating.

Robert Neill (1801–1852)
Watercolour on paper
1842
186 x 297 mm

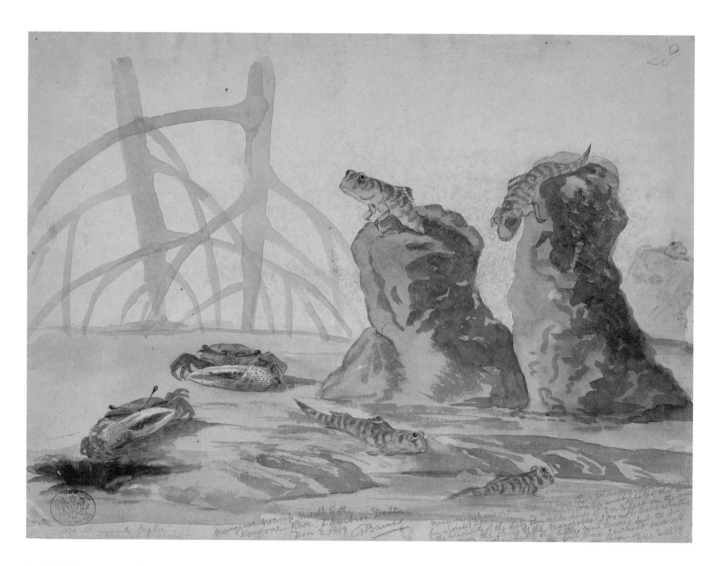

Periophthalmus sp., mudskipper

Thomas Baines undertook a sponsored expedition across northern
Australia before accompanying the explorer David Livingstone
along the Zambezi in 1858. The 155 original watercolour and pencil
sketches in the collection provide valuable insights into colonial life
and natural history in southern Africa.

Thomas Baines (1820–1875)
Graphite and watercolour on paper
1864
275 x 364 mm

Loxodonta africana, African bush elephant

This painting depicts the largest species of African elephant, the African bush elephant. It has few predators but, like many species of elephant, remains under threat from poaching. The Thomas Baines Nature Reserve in the Eastern Cape of South Africa, Mount Baines and the Baines River in Australia are all named in Thomas Baines' honour in recognition of his achievements in the field of exploration.

Thomas Baines (1820–1875)
Watercolour on paper
1870
274 x 382 mm

Alectis ciliaris, African pompano

Scottish explorer Mungo Park first travelled to Sumatra in 1793 on-board the *Worcester*, returning the following year with rare Sumatran plants for his sponsor, Sir Joseph Banks, and illustrations and notes on the new fish species that he had discovered. A feature of these drawings is the inclusion of the fin ray and lateral-line counts of the subjects. The first Westerner to have travelled to the central portion of the Niger, Park drowned following a hostile ambush during his return expedition to West Africa.

Mungo Park (1771–1806)
Watercolour on paper
*c.*1793–1794
186 x 299 mm

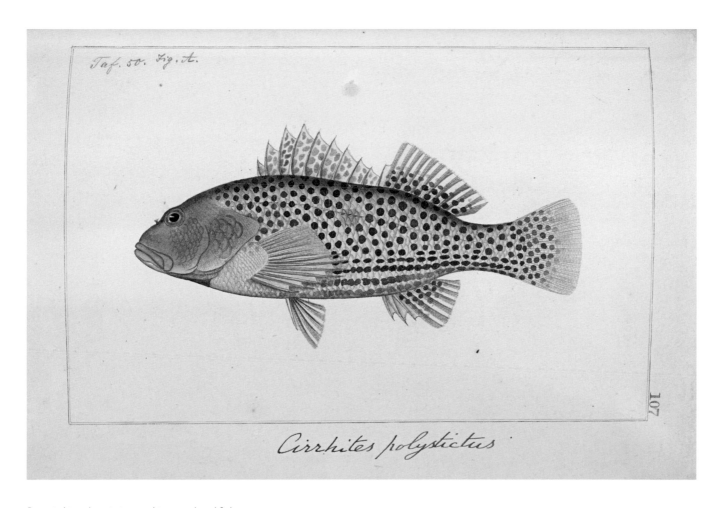

Paracirrhites hemistictus, whitespot hawkfish

American explorer Andrew Garrett spent most of his life in the South
Seas and was employed as a collector by the Museum Godeffroy
in Hamburg, which existed between 1861 and 1885. Garrett's
illustrations were used by the German-born zoologist Dr Albert
Gunther for his monograph in the *Journal des Museum Godeffroy*.
This uncommon species of hawkfish was named by Gunther in 1874.

Andrew Garrett (1823–1887)
Watercolour on paper
Mid nineteenth century
222 x 328 mm

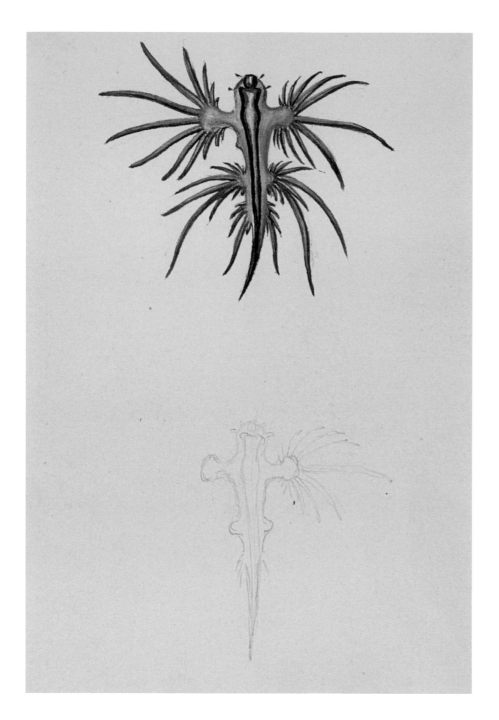

Glaucus atlanticus, sea swallow

Joseph Dalton Hooker would have observed this sea swallow floating upside down, using the blue side of its body to camouflage itself against the surface of the sea. Growing up to three centimetres in length, this beautiful delicate nudibranch is actually venomous and can cause painful stings to humans.

Joseph Dalton Hooker (1817–1911)
Watercolour on paper
*c.*1839–1845
242 x 163 mm

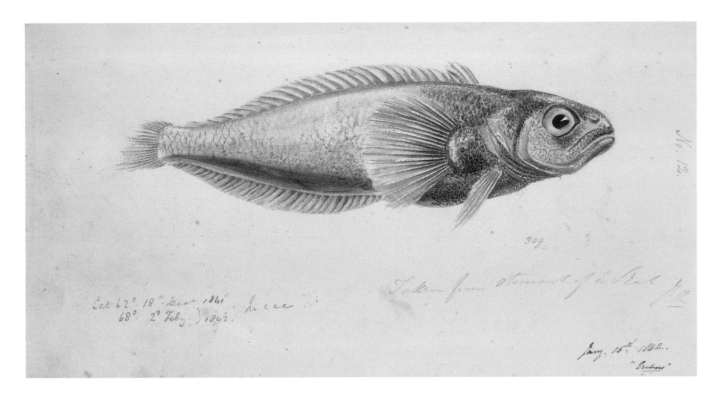

Pagothenia phocae, icefish

Regarded as one of the greatest botanists and explorers of
the nineteenth century, Joseph Dalton Hooker produced these
illustrations during his first expedition to Antarctica on the two ships
Terror and *Erebus* under the command of Captain James Clark Ross
(1800–1862). He went on to undertake many more expeditions,
firmly establishing his scientific credentials prior to his appointment
as Director of Kew Gardens from 1865 to 1885.

Joseph Dalton Hooker (1817–1911)
Watercolour on paper
1842
141 x 241 mm

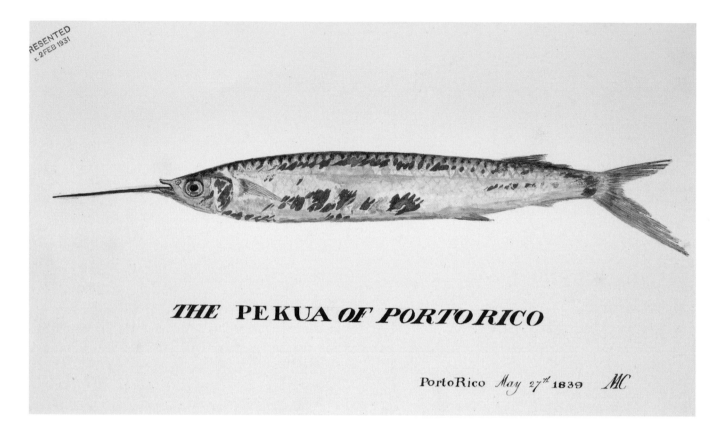

Hemiramphus sp., halfbeak

This watercolour is from a volume of illustrations of fishes, fruits and flowers that Lady Mary Anne Cust created during a tour of the West Indies, Madeira and Tenerife with her husband in 1839. Halfbeaks are predominantly marine fishes and are found in the Atlantic, Pacific and Indian oceans. They get their common names from their distinctive jaws.

Lady Mary Anne Cust (1800–1882)
Watercolour on paper
1839
249 x 423 mm

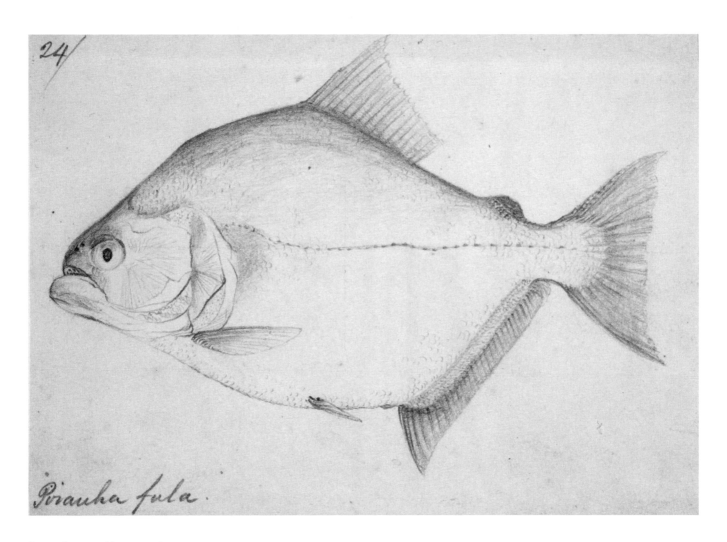

Serrasalmus gouldingi, piranha

Alfred Russel Wallace funded his expeditions through the sale of
the collections he acquired as part of his trips. In 1848, Wallace and
Henry Bates left for Brazil aboard the *Mischief* and were joined later
by Richard Spruce and Wallace's brother. This drawing is from a series
of pencil-sketches of *Fishes of the Rio Negro* and its tributaries that
Wallace presented to the Museum. None of the specimens survived a
fire on-board his ship which caused the loss of the collections he was
bringing back with him.

Alfred Russel Wallace (1823–1913)
Graphite on paper
1850–1852
110 x 150 mm

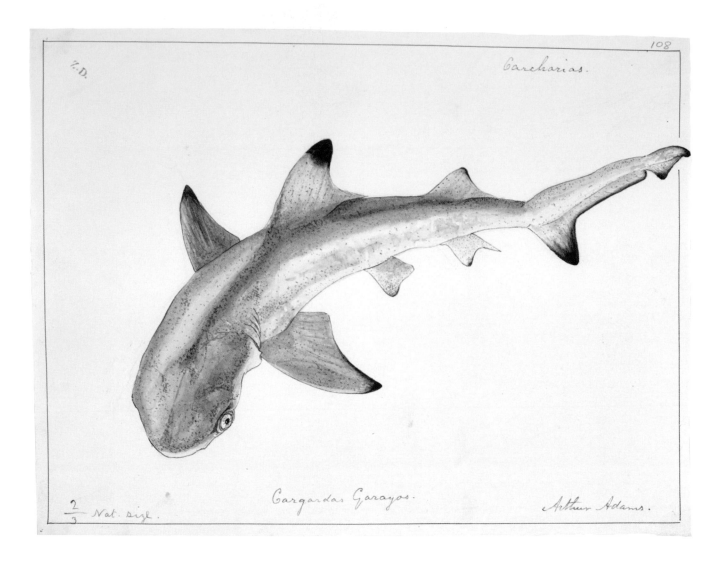

Carcharhinus melanopterus, blacktip reef shark

Arthur Adams served as assistant-surgeon and naturalist on-board
the voyage of the HMS *Samarang* (1843–1846). This illustration of
a blacktip reef shark is from a collection of 109 watercolour and pen
and ink drawings that he undertook on the voyage.

Arthur Adams (1820–1878)
Watercolour on paper
*c.*1843–1846
194 x 250 mm

TOP: *Microspathodon chrysurus*; BOTTOM: Scaridae, parrotfish

Plantagenet Lechmere Guppy was born in Trinidad, the eldest son of
the British-born naturalist Robert John Lechmere Guppy (1836–1916).
He undertook fishing expeditions in Trinidad and Tobago to collect
and illustrate its fish species. Knowing that London's Natural History
Museum was poorly represented in specimens from these areas, he
presented the Museum with some of his collections accompanied by
his notes and illustrations.

Plantagenet Lechmere Guppy (1871–1934)
Watercolour on paper
1921
284 x 200 mm

N.º 108.

N.º 34.

P. L. Guppy. del. ad nat.

Ⓧ 108. Coralreef Pomacentrus. not common. Buccoo

34. Common. Pink & grey Chub. Buccoo march & apl. 1921.

Himantolophus danae, football fish

Lt.-Col. William Percival Cosnahan Tenison was a British Army officer and talented painter and scientific illustrator. This drawing of a football fish, a deep-sea angler fish, was published in Charles Tate Regan and Ethelwynn Trewavas' *Carlsberg Foundation Oceanographic Expedition Report No 2* (1932). The ray-finned fish, *Eustomias tenisoni*, was named in his honour by Regan and Trewavas in 1930.

William Percival Cosnahan Tenison (1884–1983)
Ink on paper
*c.*1930–1932
190 x 317 mm

Fig. 5. Boleophthalmus boddaertii, Pall. One of the common shore-going Gobies of India.

Boleophthalmus boddarti, Boddart's goggle-eyed goby

This drawing is from a set of stunning pen and ink wash illustrations that the Indian artists Shib Chunder Mondul and Abhoya Cham Chowdry provided for Alfred Alcock's publication *A naturalist in Indian Seas*, published in 1902. *Boleophthalmus* is a genus of mudskipper – amphibious fish that are able to breathe through their skin and the lining of their mouth when they are wet.

Alfred Alcock (1859–1933) drawings collection
Watercolour and ink on paper
*c.*1900
108 x 178 mm

Fig. 18
Pheronema raphanus L. Bird's
Nest Sponge of the Andaman
Sea. Half the natural size.

F.E.Sch.

½

Fig. 22. Palaeopneustes Hemingi Anderson: from the depths of the Laccadive Sea. Natural Size.

Pheronema raphanus, Indian bird's-nest sponge

British naturalist Alfred Alcock completed a four-year expedition through the Indian Ocean on the Royal Indian Marine ship *Investigator*, which he joined in 1888. His publication describes his time on-board the survey ship as well as the marine biology of the Indian Ocean and is considered a classic in natural history travel writing. Artists Shib Chunder Mondul and Abhoya Charn Chowdry who worked for the Marine Survey of India provided the illustrations for his book, such as this Indian bird's-nest sponge.

Alfred Alcock (1859–1933) drawings collection
Watercolour and ink on paper
*c.*1900
147 x 97 mm

Heterobrissus hemingi, sea urchin

The artist Abhoya Charn Chowdry noted on the drawing of this echinoderm that it had been collected 'from the depths of the Laccadive Sea'. Also known as the Lakshadweep Sea, this is a body of water bordering India, the Maldives and Sri Lanka which supports a wealth of marine life.

Abhoya Charn Chowdry (*fl.* 1888–1902)
Ink on paper
*c.*1900
124 x 199 mm

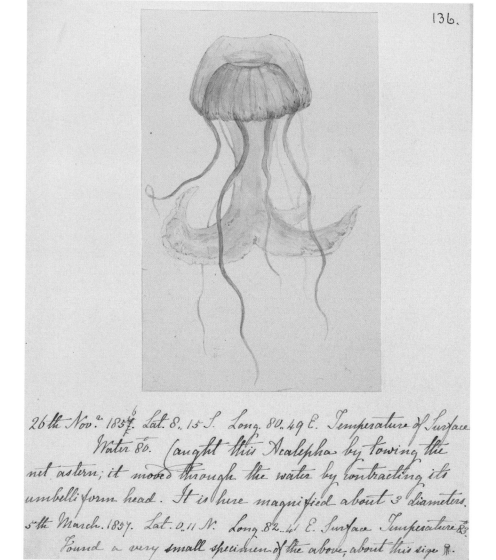

136.

26th Novᵇ 1857. Lat. 8..15 S. Long. 80..49 E. Temperature of Surface
Water 86. Caught this Acalepha by towing the
net astern; it moved through the water by contracting its
umbelliform head. It is here magnified about 3 diameters.
5th March. 1857. Lat. 0..11 N. Long 82..4 E. Surface Temperature 83
Found a very small specimen of the above, about this size ℞.

Pelagiidae, jellyfish

Mrs Henry Toynbee travelled with her husband Captain Henry Toynbee between England and India via the Cape between 1856 and 1858. During this time she illustrated and wrote observations about the marine animals and plants they encountered during their voyages.

Mrs Henry Toynbee (Ellen Philadelphia née Smyth) (1828–1881)
Watercolour on paper
1856
139 x 88 mm

Spondylus regius, regal thorny oyster

Although Sarah Stone did not travel, she used her artistic skills to illustrate objects and items that were brought back from expeditions, including from the Cook voyages to Australia and the Pacific. She was commissioned by collector Sir Ashton Lever to make drawings for his Leverian Museum. Some were of species new to science while others were objects of desire, such as the thorny oyster, which remains highly collectable today.

Sarah Stone (1760–1844)
Watercolour on paper
c.1781–1785
321 x 223 mm

TOP: Chamaeleonidae, chameleon; BOTTOM THREE: Agamidae, agamid lizards

These illustrations of a chameleon and lizards are from a volume of Illustrations produced by an unknown person 'on a voyage to Canton'. The volume and an accompanying manuscript volume containing descriptions of the illustrations were acquired by Sir Joseph Banks.

Anonymous
Watercolour on paper
Late eighteenth century
197 x 123 mm

TOP: *Clemmys guttata*, spotted turtle; BOTTOM: *Pantherophis guttatus*, corn snake

This is one of the first illustrations that William Bartram completed for the physician and collector John Fothergill who financially supported Bartram on his travels through Florida and Georgia. Bartram's style of illustration was to depict the balance found in nature and not purely focus upon the more traditional taxonomic details.

William Bartram (1739–1823)
Watercolour and black ink on paper
*c.*1769
238 x 298 mm

Index